EDWARD HOPPER
WOMEN

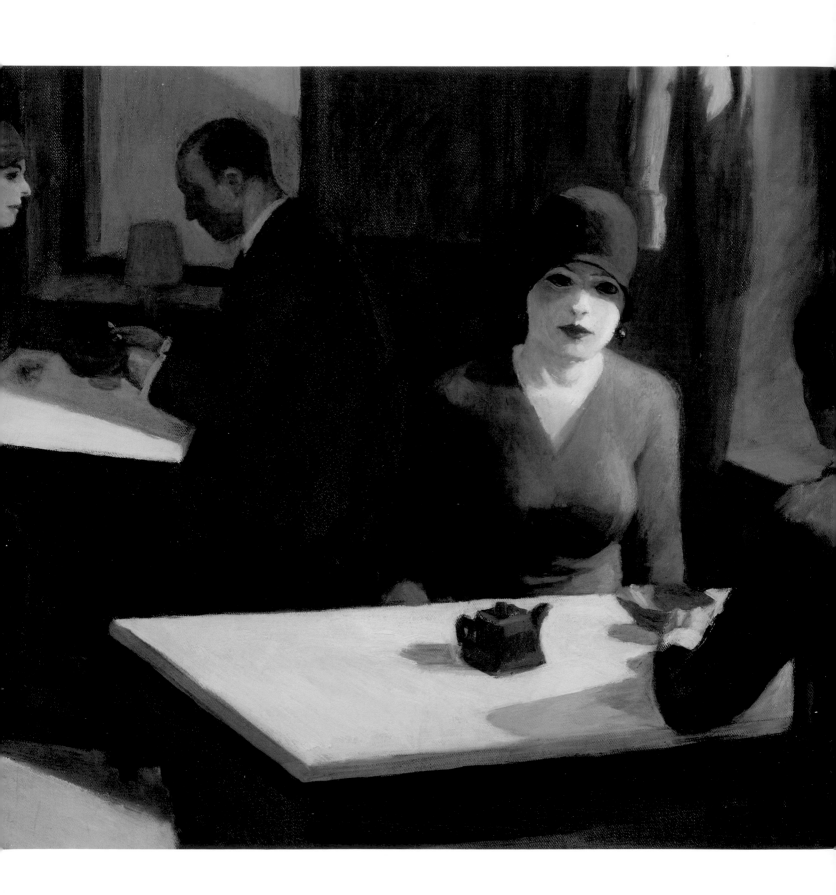

EDWARD HOPPER WOMEN

Patricia Junker

Seattle Art Museum

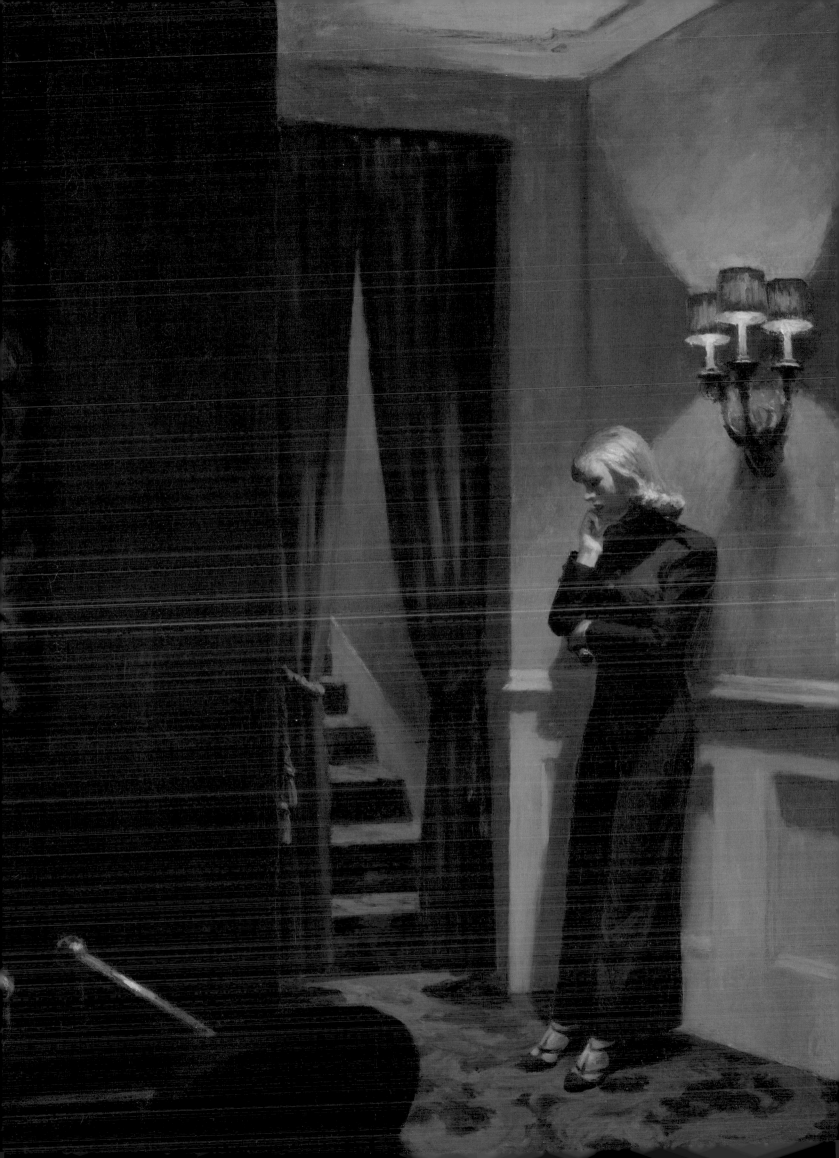

Foreword

This exhibition honors an astute collector of American art and one of Seattle's most generous art patrons, Barney Ebsworth, who is also a trustee of the Seattle Art Museum. The Ebsworth collection is one of the finest gatherings of early modern American painting and sculpture in the country, and it has helped to define a period of American art long neglected by scholars and connoisseurs. Its works have garnered such renown, collectively and individually, that it is hard to believe Barney Ebsworth was largely in uncharted waters when he set out in the 1970s to build an art collection centered on America's underappreciated early modern period. Ebsworth demonstrated his keen instinct about what represents a modern American masterwork with his early acquisition of Edward Hopper's 1929 *Chop Suey.* One of Hopper's most familiar and beloved pictures, *Chop Suey* today is rightly seen as a defining work in the artist's career. For this exhibition it provides the ideal focus for considering Hopper's enduring iconography of the modern woman.

Barney Ebsworth has always placed a high priority on sharing works in his collection with public institutions and on advancing scholarship in the field of American art. He warmly welcomes American art enthusiasts into his Seattle home and lends generously to substantive museum exhibitions. *Chop Suey* recently traveled across the country as a featured work in a comprehensive exhibition of Hopper's work; now visitors to the Seattle Art Museum can share in the painting's homecoming. *Chop Suey* will one day join other recent gifts to the museum from the Ebsworth collection—including key paintings by Marsden Hartley and Georgia O'Keeffe—ensuring that the Seattle Art Museum will be a preferred destination for students and admirers of American art.

Barney Ebsworth's generosity in sharing his collection with the public inspired other museums to make loans to this exhibition. We are grateful to the directors and staff of the lending institutions: Des Moines Art Center, Iowa; Muskegon Museum of Art, Michigan; Museum of Modern Art, New York; Whitney Museum of American Art, New York; and Yale University Art Gallery, New Haven. We also thank the private collectors who so generously parted with their treasures for the duration of the exhibition.

At the Seattle Art Museum, Patricia Junker, the Ann M. Barwick Curator of American Art, conceived the idea for the exhibition and organized it and also wrote this elegant, revealing catalogue. Patti is a consummate curator and passionate scholar. Assistance from the curatorial,

collections, and development divisions was provided by Chiyo Ishikawa, Susan Brotman Deputy Director for Art and Curator of European Painting and Sculpture; Zora Hutlova Foy, Senior Manager for Exhibitions and Publications; Heather Pederson, Exhibitions/Curatorial Publications Coordinator; Maryann Jordan, Senior Deputy Director; Jennifer Aydelott, Director of Development; Lauren Mellon, Chief Registrar; Michael McCafferty, Director of Exhibition Design and Museum Services; Traci Timmons, Librarian; and Natasha Lewandrowski, Curatorial Coordinator. Marquand Books designed and produced this catalogue; we thank our friends there for their superb work: Ed Marquand; John Hubbard, designer; and Suzanne Kotz, editor. We also wish to acknowledge the resources of the Seattle Public Library and the extraordinary help of the department of magazines and newspapers there. Outside Seattle, we had research assistance from Kristen N. Leipert, Assistant Archivist, Frances Mulhall Achilles Library, Whitney Museum of American Art, New York.

We are grateful to Safeco Insurance Foundation and to the Seattle Art Museum Supporters for their generous financial support of the exhibition, and to the Wyeth Foundation for American Art for underwriting this publication. All exhibitions are group efforts, but at the center of this collaboration is one man admired by so many in Seattle and beyond, Barney Ebsworth. This project celebrates his extraordinary achievement.

Mimi Gardner Gates
The Illsley Ball Nordstrom Director

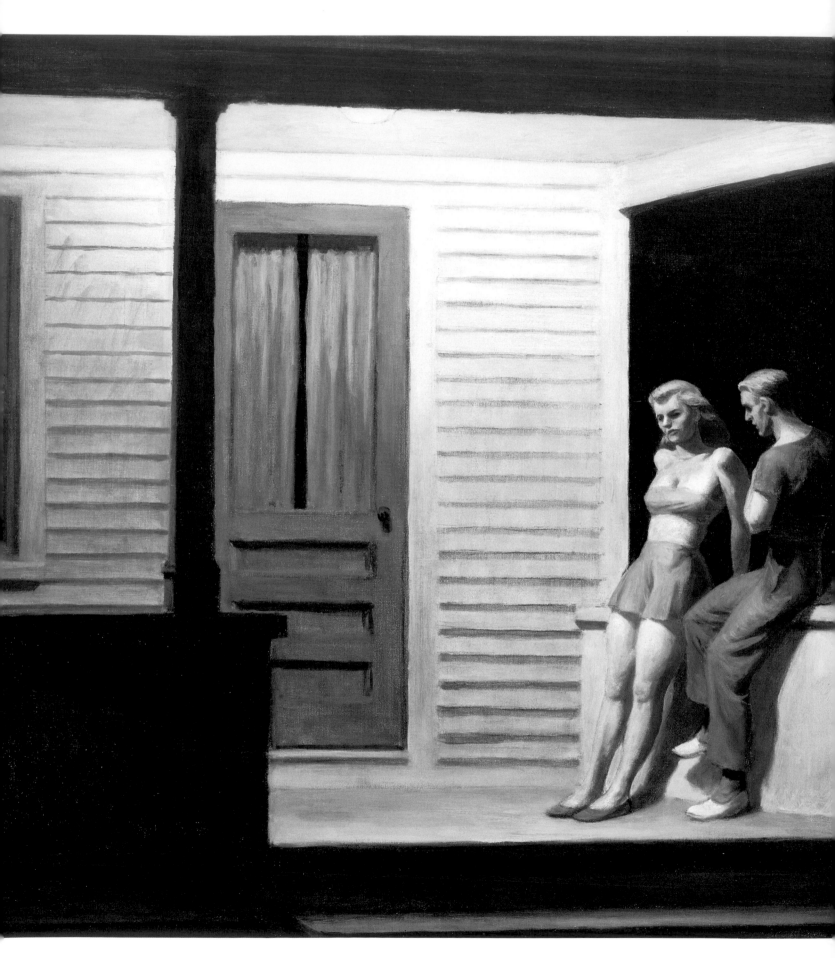

1 *Summer Evening* (detail), 1947
Oil on canvas, 30 × 42 in., private collection

The Observer and the Observed

Stare. It is the way to educate your eye, and more. Stare, pry, listen, eavesdrop.

—Walker Evans[1]

Edward Hopper (1882–1967) was a penetrating observer of the human condition. The artistic eye most akin to his, with its feeling for ordinary people so straightforwardly observed, is the photographer's lens, and it comes as no surprise to learn that Hopper admired photographers who worked in the documentary tradition. In 1956 Hopper reportedly told a *Time* magazine writer that he was at times amazed "by how much personality a good photographer can get into a picture." Among the photographers whose images intrigued him, Hopper named the Civil War chronicler Mathew Brady, whose photographs he loved "with an enthusiasm that he show[ed] for few other things in the world." Hopper also mentioned the modern Frenchmen Eugène Atget and Henri Cartier-Bresson and his American contemporaries Berenice Abbott and Edward Weston. "But most of all he likes Walker Evans," the interviewer wrote.[2]

In expressing his admiration for Evans, Hopper obliquely revealed something essential about himself. Evans produced startlingly candid photographs whose simple, honest portrayals of men and women were so without artifice that they seemed untouched by an artist's hand. Evans at times worked with a concealed camera, and he has been compared to a voyeur, an assertion that suggests the intimacy and even the invasiveness of his snapshots. Hopper shared Evans's obsessive curiosity about the unrevealed self; Hopper, too, took the part of the voyeur to find his subjects: "He likes to look in windows and see people standing there in the light at night. . . .

He likes to ride the els. He would like to get into the apartments but there's no excuse," a reporter wrote in 1935.[3] Hopper would have seen raw human nature in Evans's art—human nature as it is exposed in unguarded moments, glimpsed either innocently in passing or through outright staring. The painter must have envied the seeming ease with which the photographer could catch the unconscious actions of the men and women who came before his lens. Speaking to critic Brian O'Doherty in 1964, Hopper would decry "the imperfection of the means" by which a painter transcribes his visions, complaining that "the inert brute matter of the pigment annihilates the idea or memory, or precursory image as it is given form."[4] A few years earlier he matter-of-factly told *Time* magazine, "I've never been able to paint what I set out to paint."[5]

Both men, Evans and Hopper, each reticent by nature, would acknowledge their eventual mastery of the art of staring, as Evans would call it, that determined focus that is not simply a means toward the accumulation of visual data but which isolates the object of scrutiny and stirs the imagination. But how does the painter play the unobtrusive bystander, as the photographer could, seeing and recording those revealing split-second human actions, interactions, and expressions (fig. 1)? How does the painter stare unabashedly and unnoticed at other men and women that he might make a picture of their unguarded selves?

"I used to go to the cafés at night and sit and watch," Hopper said of his formative experiences in Paris from 1906 to 1910 (fig. 2).[6] A student of

Figure 1. Morris Engle (American, 1918–2005), *Sweet Evelyn, New York City,* 1938
Gelatin silver print, 13⅛ × 10⅛ in., The Museum of Fine Arts, Houston, museum purchase with funds provided by the Polaroid Foundation

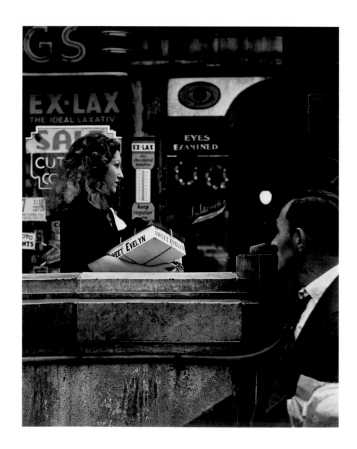

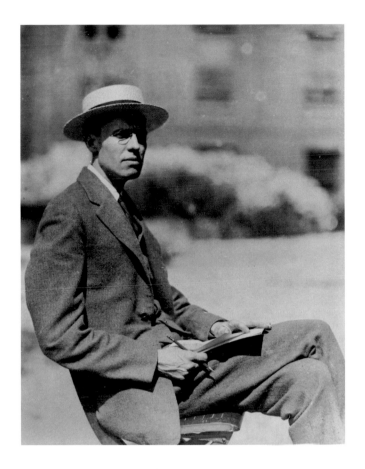

Figure 2. Edward Hopper
in Paris, 1907
The Arthayer R. Sanborn Hopper
Collection Trust, 2005

Robert Henri at the New York School of Art, Hopper had excelled at figure drawing and painting. His early portraits, self-portraits, and art class studies of fellow students show his uncommon sensitivity to body language, facial expression, and the character of a figure's clothes and surroundings. He was a skilled observer and draughtsman by the time he got to Paris, but he lacked the personality for engaging men and women on the street. "Timid as an English school boy" is how his close American painter-friend Guy Pène du Bois described him. "Too much Anglo-Saxon reserve."[7] The image that we get of the young, self-conscious Hopper in bohemian Paris in the early years of the twentieth century is not unlike that offered by Walker Evans of himself in Paris in the 1920s. Evans, a reticent Midwestern youth from a time, place, and family that held American Victorian-era values dear, was suddenly shaken out of his inhibitions by his encounters with the audacious Europeans of the café crowd:

> I remember my first experience as a café sitter in Europe. *There* is staring that startles the American. I tried to analyze it and came out with the realization that the European . . . is *really* interested in just ordinary people and makes a study with his eyes in public. What a pleasure and an art it was to study back, and a relief to me as a young more or less educated American, with still echoing in the mind his mother's "Don't stare!" (I still can't point at *any*thing in public.) But

I stare and stare at people, shamelessly. I got my license at the [café] Deux Magots . . . where one escaped one's mother in several other senses, all good, too.[8]

Hopper himself was a figure that invited a café sitter's stares. He was tall, folding a six-feet-four-inch frame into his seat, and he was big; he was uncommonly handsome, too, with a large, sculptural head and a chiseled face: "Great prominent masticating muscles, strong teeth, big mouthed, full-lipped," Pène du Bois described him.[9] Hopper stood out among the Frenchmen—they are "small and have poor physiques," he noted.[10] His café sketches show that the objects of his curiosity were often those who stared at him, especially the fetching women of the street and the demimonde, fixtures of café society. If he was self-conscious at first, he somehow overcame his reserve. As these women of the cafés stared seductively at him (figs. 3, 4), Hopper came to learn and enjoy the fine art of staring back.

For Hopper, fixation—on people, especially—became the foundation of his creative process. Pictures evolved from memories more than they did from notes or sketches. Writing to the American museum director Charles Sawyer in 1939, Hopper explained one of his compositions: "The picture was planned very carefully in my mind before starting it, but except

Figure 3. *Woman Seated at Café Table,* 1906–7
Watercolor and graphite on board, 19⅞ × 15 in., Whitney Museum of Art, New York, Josephine N. Hopper Bequest (70.1379)

Figure 4. *Woman at Café Table,* 1906–7
Watercolor and graphite on board, 20 × 14⅞ in., Whitney Museum of Art, New York, Josephine N. Hopper Bequest (70.1372)

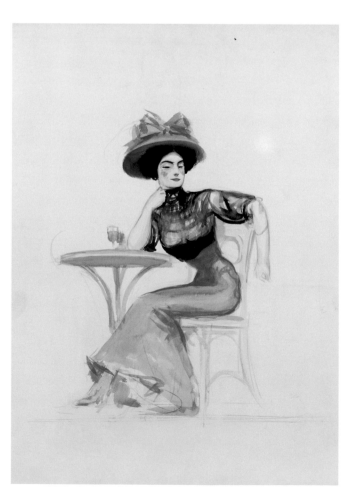

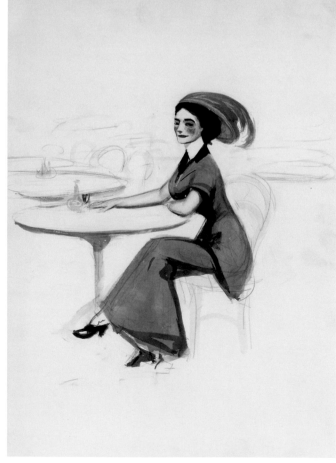

for a few small black-and-white sketches made from the fact, I had no other concrete data, but relied on refreshing my memory by looking often at the subject."[11] His pictures became records of visual sensations that remained vivid in Hopper's imagination and whose emotional impact grew over time. As some elements of the memory faded and others intensified, a process of editing the experience into a picture was underway. For Hopper, making paintings required a long period of gestation. He was not just a slow painter, either; he was slow to come to painting. Early in his career, he painted in fits and starts and then settled into commercial illustration before dedicating himself to the art of etching. His first success as a painter came when he was well into his forties. He had spent a great deal of time getting ready to paint the pictures that would appear to be simple snapshots of people and places.

The objects of Hopper's curiosity are what distinguish his art. In rendering figures and scenes in a deadpan, even artless, manner, he managed to make his subjects the object of our scrutiny—much like Walker Evans's candid photography. The wonder of his paintings is that Hopper's fixations seem so perfectly at times to match our own, as though in his art he has revealed a viewer's own deeply personal visions and thoughts. "Hopper . . . paints not only what Americans have seen from the corners of their eyes, but also what they have dimly thought and felt about it," *Time* magazine said in 1956.[12] As Brian O'Doherty put it, "all of us have such moments in life, and Mr. Hopper's pictures . . . recognize and re-create such very intimate but very common moments." He elaborated:

> Of all the buildings seen along a route in a journey, we find there is one we remember, while with the passage of time, the rest of the experience fades like a negative. Or a glimpse through a lighted window, intensified, like all perceptions, by framing, takes on a sudden meaning before lapsing into prosaicness. Or a face seen momentarily among thousands of anonymous faces, assumes an inexplicable importance in memory. There are those moments of recognition when we stop a car in a strange place, and move on again, haunted by a troubling sense of familiarity.[13]

For all their familiarity, however, the fixations, we must remember, are those of the man—of Edward Hopper. The paintings represent one man's private encounters and memories. In them are revealed the obsessions of a man who famously shared little. Of the meaning of these pictures, Hopper would say little more than "the whole answer is there on canvas. I don't know how I could explain it any further."[14] What makes his pictures such rich fields of psychic drama is the tension residing in the relationship of Hopper to the observed, in the secret life of a quiet man who would sit and stare.

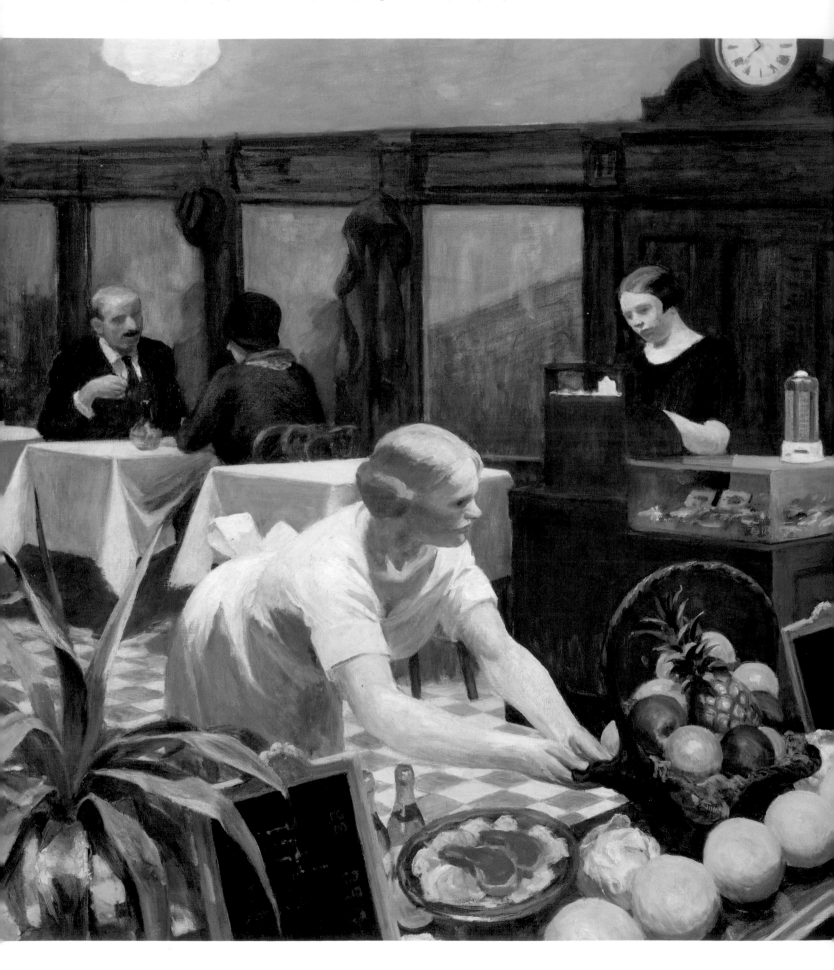

Figure 5. *Tables for Ladies*, 1930
Oil on canvas, 48¼ × 60¼ in., The Metropolitan Museum of Art, New York, George A. Hearn Fund, 1931 (31.62)

Tables for Ladies

Edward Hopper and Café Sitting in New York in the 1920s

The only force which is strong enough to break down social convention is economic necessity. . . . The economic necessity which has forced women out of the home and into the world of business has completely annihilated the old idea that a woman should eat only in the privacy of her own household or in the homes of her friends. . . . Nobody fought for it, but some way or other the significant sign— momentous portent of the future—"Tables for Ladies" began to appear in restaurant windows.

—*New York Times*, October 15, 1905[16]

Edward Hopper found some of his first New York subjects in restaurants. He had been a café sitter since his early years in Paris, where the cafés of bohemian Montmartre had been something of an artist's studio for him. There he could study and draw any number of willing models ready to strike a pose or adopt a persona. Hopper could simply sit, as others did, and watch the parade of colorful characters who traversed this impromptu stage: dandies, rogues, rakes, dancers, actresses, shop girls, and harlots. Cafés were convenient places for Hopper to hone his skills as an observer and recorder of character types, but in their social dynamic they offered something more. As casual meeting places for socially and sexually uninhibited men and women, Paris cafés presented a continuously unfolding and highly charged, if ambiguous, human drama. The shy, young, Baptist-reared Hopper may have been content to watch from the periphery, but he became thoroughly absorbed in this strange, decadent theater of the street.

Cafés were places to stir an artist's imagination and to stimulate a young man's psyche. In New York, the unpretentious restaurants around his Washington Square flat and studio in Greenwich Village supplanted the cafés Hopper had enjoyed in Paris. The New York cafés catered to the needs

of working-class men and, increasingly, women. As young men and women poured into the city to jobs in shops and offices, they required comfortable restaurants for cheap daily meals at lunchtime and for late supper. Saloons, which had traditionally served workingmen their supper and libations, were no places for women. The advent of Prohibition in 1919 ensured that these controversial establishments would close and spurred enterprising saloon-keepers to transform once rough and raucous watering holes into respectable lunch counters, tea halls, and dining rooms, all designed to serve an ever-growing female clientele.

In such restaurants a keen observer like Hopper would see reflected the changing face of the American woman. Victorian-era rules of feminine behavior were quickly being discarded in Manhattan's casual eateries. "Dining out" for a proper woman traditionally meant eating in the company of a suitable escort lest the lady be taken for a prostitute, for restaurant diners were typically only male businessmen or travelers. Some uptown restaurants still subscribed to that notion and did not welcome the woman who dined alone, fearing that her presence would raise suspicions and sully the reputation of a respectable establishment. Without an express invitation to enter, a woman alone knew not to venture into just any public dining room—she knew where she was welcome and where she was not. When the discreet but friendly sign "Tables for ladies" began appearing in windows (figs. 5, 6), it signaled a restaurant's acceptance that society was changing. The morals and motives of an unescorted woman were no longer automatically questioned, and she was not shunned in a public dining room.

The placard "Tables for ladies" also indicated a place of refuge for the young working woman desiring a comfortable, unthreatening environment in which to take her lunch and supper meals, a place where the

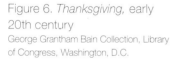

Figure 6. *Thanksgiving*, early 20th century
George Grantham Bain Collection, Library of Congress, Washington, D.C.

stranger sitting next to her would most assuredly be a friendly female companion and not, as a woman alone might understandably fear, a predatory male. "Tables for ladies" was an especially reassuring sign in the cheaper eateries suited to the budgets of young shop girls, typists, and stenographers who wanted to avoid male riffraff.

Hopper's first New York paintings are about restaurants, but they are more specifically about women, not surprisingly, perhaps, because single women—women diners and women servers—were new and ubiquitous fixtures on the restaurant scene. In New York's restaurants, women, especially young ones, were on public display as never before. Hopper's restaurant pictures all focus on these young working-class women, and thus they underscore something essential about the character of the modern city in which he painted. They reveal, too, the social and sexual tensions that came with new public roles for men and women. Hopper's New York café women of the 1920s are among his most psychologically and sexually charged character studies, and they tell us much, too, about the intensity of his own personal engagement with his subject.

New York Restaurant, c. 1922

When Hopper's *New York Restaurant* (cat. no. 2) was exhibited at Philadelphia's Pennsylvania Academy of the Fine Arts in January 1923, the artist, at age forty, was still little known as a painter. Only occasionally had he shown paintings in the years since his return from Paris in 1910. He displayed promise when his canvas *Sailing,* of 1911, was included in the International Exhibition of Modern Art in New York—the famous Armory Show of 1913—and even found a buyer there, marking his first sale. Subsequently his teacher Robert Henri organized periodic exhibitions of the work of his protégés and in them included Hopper's paintings, but these selections failed to garner attention for Hopper. In 1920 Guy Pène du Bois, a close friend of Hopper's and a devoted advocate of his work, organized a solo exhibition that included a sizeable representation of Hopper's oils—sixteen canvases, primarily Paris scenes dating from a full decade earlier—along with the recent etchings for which Hopper was better known. Yet the modest canvases attracted little interest.

Hopper's submission to the Academy show in 1923 was an unassuming work, a small canvas offering an unremarkable look inside a typical Manhattan restaurant at lunchtime. In a show dominated by ever-popular romantic figure pictures and brightly colored, vigorously painted postimpressionist-style landscapes, Hopper's *New York Restaurant* was fresh in its realism, but in the context of the exhibition, it might have seemed akin to other light-hearted, postimpressionist genre pictures, given its breezy

2

New York Restaurant, c. 1922
Oil on canvas, 24 × 30 in., Muskegon Museum of Art,
Hackley Picture Fund Purchase (1936.12)

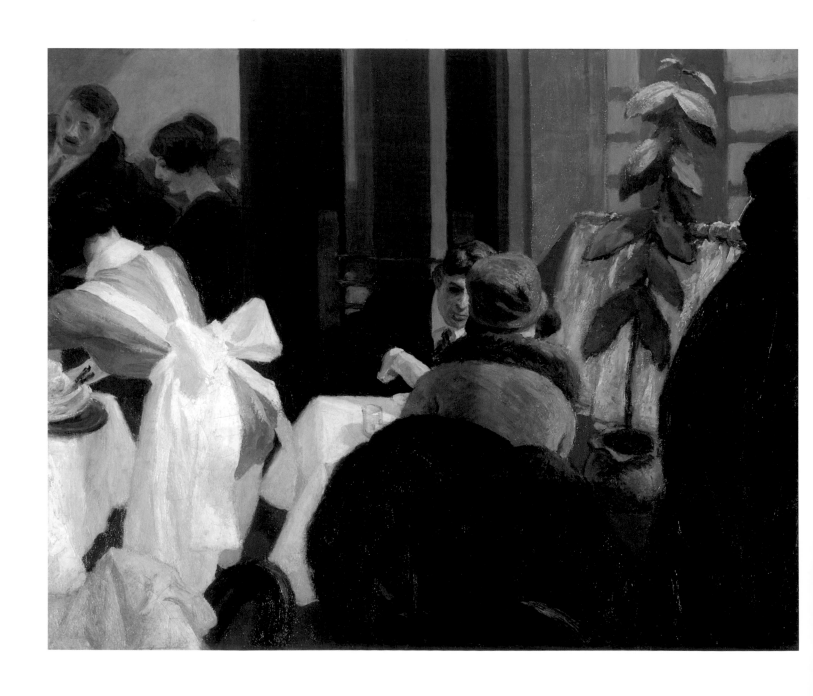

subject and tactile paint handling, a kind of brushwork that Hopper would soon abandon.

Years after he unveiled the picture, Hopper offered a typically understated but loaded explanation of the subject of *New York Restaurant:* "In a specific and concrete sense the idea was to attempt to make visual the crowded glamour of a New York restaurant during the noon hour. I am hoping that ideas less easy to define have, perhaps, crept in also."[16] Hopper placed a premium on subtlety. There is more here than meets the eye, he said.

Hopper's restaurant seems to be an authentic transcription of the look and feel of a pleasant Manhattan dining room in the 1920s—a good uptown place, perhaps, where businessmen lunched. It is respectable but not pretentious, a place with white linen tablecloths and sprightly, young, well-groomed waitresses who wear pretty starched uniforms—no dour male servers here. Though Hopper narrowed our view of the room to focus on only a few figures, we can easily imagine the room beyond our frame of vision crowded with diners, habitués perhaps, who fit unselfconsciously into this scene. If there are tables for unescorted ladies at this genteel establishment, we do not see them. This lunchroom is a man's realm, where the only women present are either servers or consorts.

Figure 7. *In a Restaurant,* c. 1916–25
Conté crayon on illustration board, 26¾ × 21⅝ in.,
Whitney Museum of American Art, New York,
Josephine N. Hopper Bequest (70.1449)

In the tightly cropped composition, Hopper offered three vignettes: at center, a man and woman dine, wholly absorbed in one another; at left, a shapely waitress with her back to the viewer clears an adjacent table; and at upper left, on the periphery, two cut-off figures who appear to be a departing male customer and the restaurant's cashier—a pretty young woman, plainly dressed, standing at her station near the door. None of the figures acknowledges the viewer; Hopper shows us men and women who are wholly unaware that they are being watched. There is no defining action, either—this scene is but one typical and unremarkable moment in the course of lunchroom events. As we look at this vignette and its players, we puzzle over the picture's context. Who are these anonymous people? What sequence of events has brought them together, and what will develop from their interaction? As a magazine illustrator, Hopper was adept at creating graphic images with clear, succinct, and dramatic story lines (fig. 7), but in *New York Restaurant* he avoided melodrama or anecdotes. The picture is oddly fragmentary and ambiguous, even hard to read. Its ill-defined spatial planes press flat against the surface, an effect that forces the viewer to register a multitude of visual data without the benefit of direction from perspective or light and shadow. The painting is suggestive rather than narrative, its appeal more psychological than sentimental.

Hopper has put the viewer into the picture, too, at the edge of the scene, seated at the table just in front of the couple at center. They sit in the viewer's direct line of sight, and yet we feel that this couple, so deeply engaged in one another, might be wholly inconspicuous were it not for the woman's striking red hair, her crimson cloche, and her fur-collared coat. The viewer stares at the back of the red-haired woman, only imagining her beauty, while glimpsing, too, the face, but not the full expression, of her gentleman companion. For all our close and concentrated scrutiny, the two reveal little about themselves and nothing of the intimacy they share.

The viewer's fixations color the mood of this bright picture. His or her gaze moves back and forth between the sensuous backside of the waitress at left and the head, hair, and soft round shoulders of the female diner at center. Both are oblivious to this intent scrutiny, and after a while one feels the indignity that such invasive staring brings upon these unsuspecting young women.

Is there a moralizing undertone to Hopper's *New York Restaurant?* Restaurants catered to men's private obsessions as well as to their public dining needs, and in the 1920s restaurateurs increasingly employed young women servers to entice and amuse male diners with suggestive teasing. Working girls were always vulnerable to predators, even in the most respectable dining rooms.[17] Hopper further knew from his experience among the café crowd that a young woman dining as the guest of an older man likely signaled a solicitation and not a proper courtship. Even when Prohibition

3

East Side Interior, 1922
Etching, 8 × 10 in (plate), private collection

4

Evening Wind, 1921
Etching, 7 × 8⅞ in. (plate), private collection

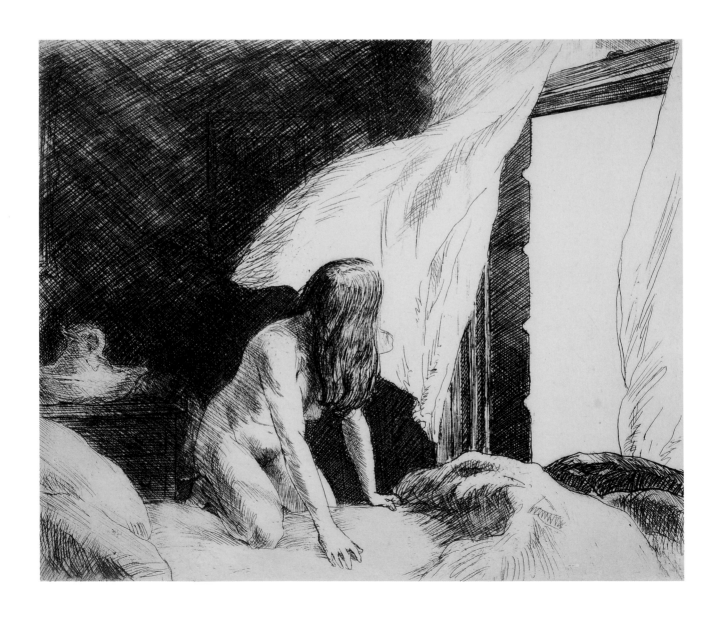

closed the saloons, where prostitution had been rampant, solicitation of women for sex simply moved out of the cellars and into the light of day, even, Hopper must have believed, into so-called proper lunchrooms. For Hopper's audience in 1923, the intimate couple in *New York Restaurant* may have invited such a topical reading.

And what might *New York Restaurant* reveal about Hopper himself? Artistically, the painting suggests that his imagination had reached a new stage. Hopper had long sought to build a reputation on his plein-air Paris city views, but he now turned inward, studying interiors, examining private spaces where his internal musings could play out. *New York Restaurant* is key in establishing the direction Hopper's art would take henceforth.

Hopper's own intimacies in 1922 are hard to gauge. Middle-aged and unmarried, Hopper seemed to his friend Pène du Bois to exude a "hunger" that might be ascribed to a yearning for closeness. "Should be married," Pène du Bois wrote of Hopper in his diary in 1918, "but can't imagine to what kind of a woman. The hunger of that man."[18] Beginning around 1918, Hopper had become fixated on a French woman who is the subject of a succession of sketches and prints: head studies from the front and back and in profile, and a few intimate figure studies, too, which show affection and tenderness. Hopper may not have disclosed this friendship to anyone, and the true tenor of the relationship is not known, but Hopper seems to have cherished his time with this woman, keeping until the end of his life his sketches of her, along with her gift to him of a volume of poetry by Paul Verlaine, which she presented to Hopper at Christmas 1922, inscribing it a "souvenir d'amitié."[19]

As model and muse, Hopper's French friend may have been the inspiration for an evolving series of prints in which the artist focused with increasing intensity on solitary women glimpsed in intimate settings. The series included *East Side Interior* (cat. no. 3) and the sexually charged *Evening Wind* of 1921 (cat. no. 4), depicting a naked girl provocatively revealing herself in the privacy of her bedroom at night. *Evening Wind* gave way to an equally erotic nocturnal oil, *Moonlight Interior* (1921–23, private collection), in which the object of a surreptitious onlooker's gaze is the naked body of a fleshy, auburn-haired woman.[20] Is she the red-haired woman who appears at the center of Hopper's *New York Restaurant*? If so, the woman of Hopper's extended fantasy has moved from the shadows to a table in a proper uptown dining room, where she sits unabashedly with a gentleman companion in the brilliant light of noontime. Was Hopper, in this puzzling little canvas, giving form to his own fantasy, wherein he might no longer be the man who sits alone in the lunchroom and stares? Is this a long-imagined moment, when Hopper no longer conceals his passion but sits unselfconsciously in broad daylight with the seductive object of his desire, the two of them sharing an intimacy that no one else could know?

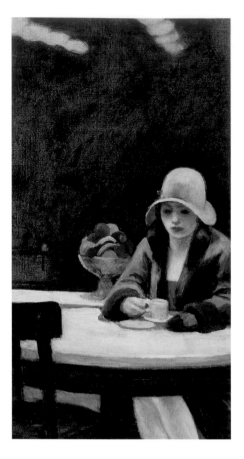

Automat, 1927

Manhattan's large Automat restaurants offered tables exclusively for ladies, an accommodation made to the thousands of single women who daily turned to these dining emporiums to get a good meal at an unbeatable price. Automats were, proudly, the everyman's dining room—and they were every working woman's dining room, too. The self-service Automat restaurant has disappeared from the city that made it an icon of the machine age, but in its heyday, in the decades between the world wars, the Automat was the modern world's most original dining invention and a great social equalizer in the largest and most diverse city in America.

The Automat got its name from its novel automated service. A precursor to the modern vending machine, it was a far cry from the connotation that food vending has today. The expansive Automat dining room was lined with rows of gleaming cubicles faced with glass, behind which were fresh, appealing foods that had been prepared in an adjacent commissary to exacting, home-cooked standards. One could choose among simple hot dishes like macaroni and cheese or even more exotic fare like lobster Newburg, or select from an assortment of cold sandwiches and an array of home-made desserts. Diners dropped nickels into slots beside the windows displaying the items they desired; the windows opened, and their contents could be retrieved. Each selection was instantly replaced by another serving of the identical offering, thanks to a mechanized device that kitchen workers carefully loaded out of sight of the customers. Service in the Automat was transacted "with a precision and dispatch impossible to human waiters," one astonished visitor wrote.[21] But quality, consistency, and variety were also hallmarks of the Automat experience and were the secret of its wide appeal across all economic segments of Manhattan society.

Automats sprang up throughout the city in the 1910s and 1920s, and each came to serve thousands of diners every day in dining rooms that often ranged across two floors, at street level and below (fig. 8). One Automat under construction in the Yorkville district on the Upper East Side in December 1927 was built for a daily capacity of ten thousand diners.[22] Ironically, the most democratic dining emporiums in Manhattan were also among its most opulent and inviting. With their enormous self-service dining rooms, Automats were famous for their dazzling interiors. The *Brooklyn Daily Eagle* reported on the amazing opulence of one of the first Automats to open in Manhattan in 1902:

> The Automat restaurant at 830 Broadway is about a hundred feet long and about 25 feet wide. The eye is at once arrested by a combination of mirrors in round and oval disks and various shaped fragments of glass, each particle framed in nickel, together with hard wood, akin in color to lignum vitae, above which is a mosaic frieze of inlaid natural

and painted woods showing old rose, goblin blue, burnt orange, terra cotta, sage green, and other effects. . . . The fitting up of the whole cost upwards of $75,000.[23]

The famous Horn & Hardart Company's first New York Automat, in flashy Times Square, featured a magnificent stained-glass window stretching thirty feet wide and two stories high, its intricate motifs of fruit and flower garlands framing the giant word "AUTOMAT" at its center. Inside, diners sat at elegant marble-topped tables that held condiment-laden "lazy Susans," a Horn & Hardart trademark.[24] Marble floors, mirror panels, polished walnut chairs, stunning arrangements of incandescent lights—all these details combined to make the Automat nothing less than a dining palace.

Large windows showed off the elegant interiors to passersby on the street. Always brilliantly illuminated, Automat dining rooms were beacons in the dark to diners who wished to sup at any hour of the night, or who might simply want to come in out of the cold and have nothing more than a good five-cent cup of coffee. As further enticements, windows usually held large compotes brimming with mounds of fresh fruit, clear symbols of the assured freshness and sumptuousness of the offerings to be found within.

The Automat quickly became beloved by many New Yorkers for its novelty. But for some it represented the dark side of the new machine age. The Automat was emphatically impersonal, and the efficiency that was its

Figure 8. Horn & Hardart Automat interior, undated

Robert F. Byrnes Automat Collection, Manuscripts and Archives Division, The New York Public Library, Astor, Lenox, and Tilden Foundations

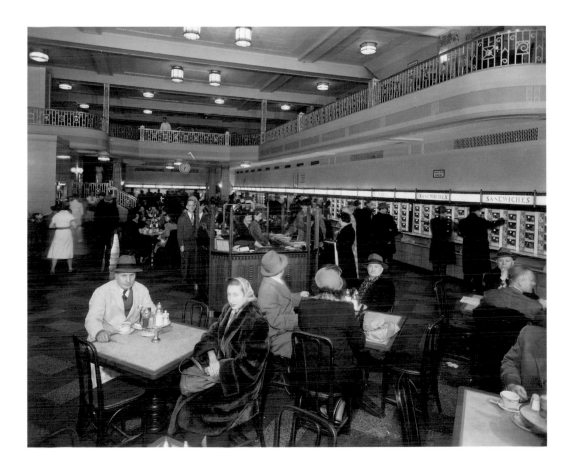

great virtue was increasingly viewed as something insidious. Its very name implied a mechanism whose function was to process legions of individual diners through a perfectly regulated system, day in and day out. Crowded dining rooms, with thousands of lunchtime diners, fostered fierce self-reliance and self-interest among the wary strangers. These halls could be joyless and soulless spaces, the epitome of a city that moved so fast it offered little time or opportunity for meaningful human contact. At its worst, it was an affront to the very men and women it was dedicated to serve: these emporiums that catered to the working classes were feared as labor's worst nightmare, an enterprise run largely by machines. Even table service was dispensed by a contraption whose popular name, the lazy Susan, disparaged not only the cooks and servers whose efforts behind the scenes were the secret of the Automat's efficiency but especially the women workers who comprised the largest segment of the Automat's clientele.

The popular mythology of the Automat often addressed its meta-phorically dark aspects, making these restaurants synonymous with the pathos of the modern age, a symbol of the loneliness and despair of men and women who had lost so much on the road to the high life in the big city. Frequently it was a young woman who was the most poignant character in the fictional, modern-day human dramas that were set against the back-drop of the Automat restaurant. She was a touching reminder of the cultures that collided in the vast, populous Automat dining rooms in the early twentieth century, a figure caught between the straightlaced Victorian age and the freewheeling modern era and—as an immigrant woman most likely—a figure who also lived between the Old World and the New. Among those who gave voice to so many young girls sitting silently in the Automat was Florence Van Cleve, a social observer and amateur poet who contributed the plaintive ballad "At the Automat" for readers of the *New York Times* in November 1925:

> Here I sit
> At a small table with a marble top,
> A sign, "reserved for Ladies," in the place
> Where you always had flowers. Not a face
> Of all the faces that now come and go
> In such bewildering crowds has eyes for me.
>
> These crowding forms,
> What are they, really, but automata?
> They come here to be wound up for the day;
> And then machine-like they go through their motions
> Till evening comes; then they are all run down
> And wait the next day's winding.

Little home
Up there among the hills, how near you seem
To heaven, as I watch the hurrying crowds
That eat their breakfast at the Automat.[25]

In June 1926, another writer—a male poet—offered *Times* readers
a sad commentary on their place and time, versifying a cautionary tale for
all the young ladies who might still yearn for a different life in the big city.
Therein he enlisted the Automat as one of the degradations that a girl alone
endured in an inhospitable, if not immoral, urban world:

Lonesome, lassie, did you say,
In your homeland far away . . . ?

There you're stranger to the smart
That besets the urban heart,
Walking here where millions run,
Daring not to speak to one . . .

Living, for a year or more,
Stranger to the man next door;
Watching greed and fraud grow fat;
Dining in an automat . . .

Watching beauty pass me by,
Daring not to let my eye
Pay its tribute, just for fear
Retribution's standing near;
Knowing that one-third of all
Speak no language at my call
Thus, where millions throng the mart,
Living like a thing apart.[26]

In giving the title *Automat* to his otherwise ambiguous restaurant
picture (cat. no. 5), Hopper understood the emotional response it would
elicit among viewers for whom the Automat was not just an eatery but the
embodiment of what was good and evil in their modern urban world. His
subject is not the restaurant itself, for Hopper has shown us nothing of the
gleaming dining hall and its walls of mechanical glass windows. His subject
is simply a young woman in a bright green, fur-trimmed coat and yellow
hat, who sits alone at a table for two in the window of a brightly lit café.
The scene is tightly cropped. We see little beyond the sitter's immediate
space at the front of the restaurant. The viewer would seem to occupy

5

Automat, 1927
Oil on canvas, 28⅛ × 36 in., Des Moines Art Center
Permanent Collections, purchased with funds from the
Edmundson Art Foundation, Inc. (1958.2)

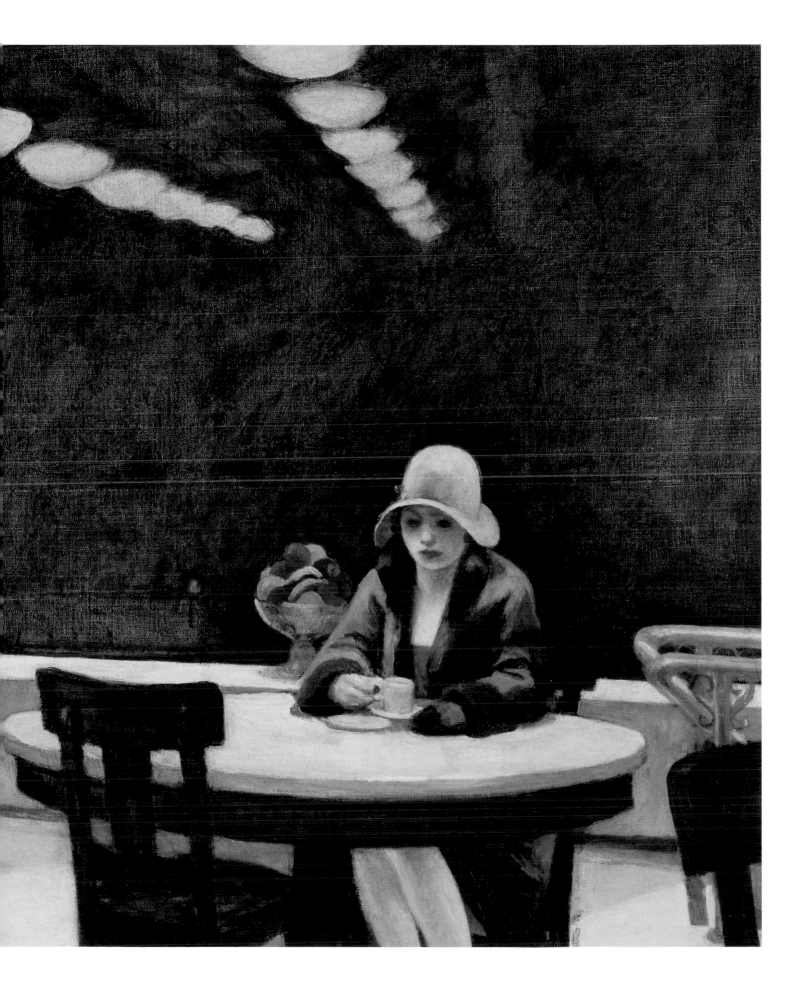

6

Sunlight in a Cafeteria, 1958
Oil on canvas, 40¼ × 60⅛ in., Yale University Art
Gallery, New Haven, bequest of Stephen Carlton Clark,
B.A., 1903 (1961.18.31)

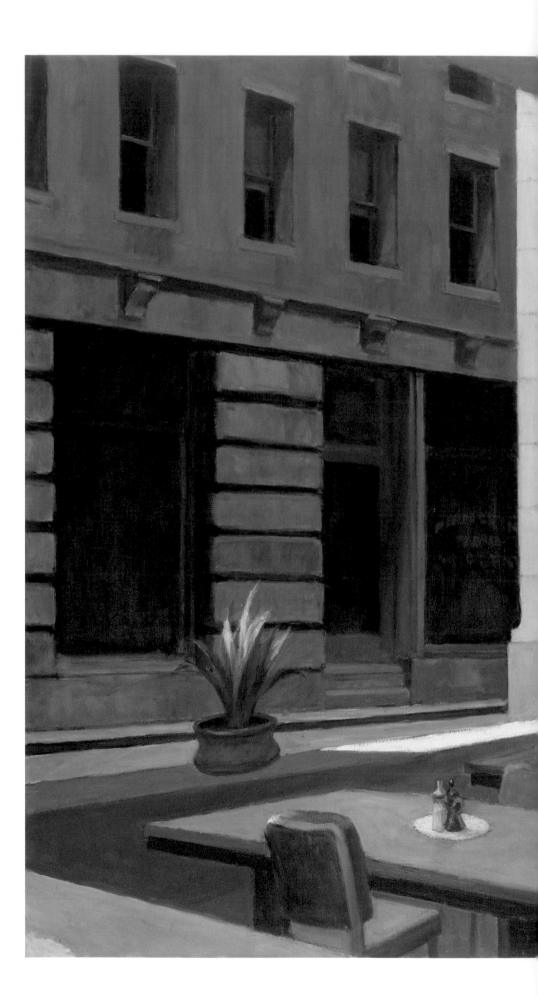

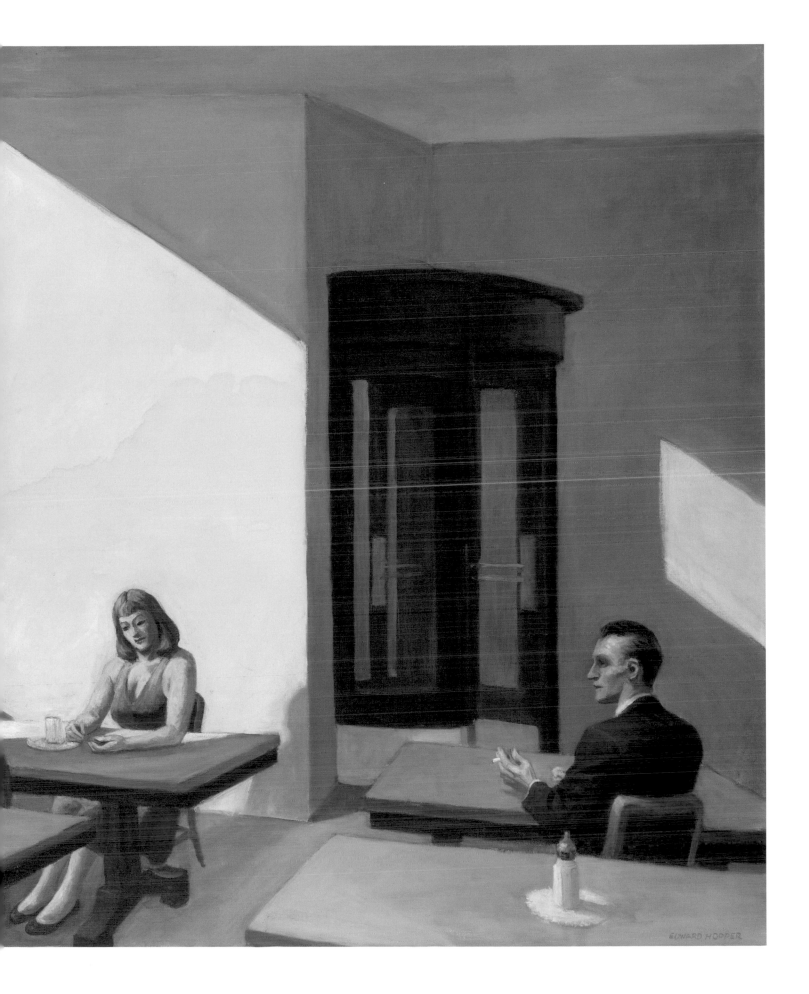

a seat at a table just outside the frame of vision, opposite a wide window so impenetrably dark that we can see only the reflection of the room behind us. But even the reflection shows nothing but the rhythmic linear pattern of long rows of round ceiling lamps hanging overhead, extending far into what must be a very large room. The scene is engulfed in emptiness.

We are so close to the young woman, and the scene is so spare, that we cannot help but notice small things. Her eyes are downcast. She has removed one glove, and with her bare hand she aimlessly fingers her coffee cup. She sits near the radiator, but she wears her coat and has pulled her fur collar up around her neck and cheeks, for the bodice of her dress is low and so much soft, white, youthful flesh is exposed. She has positioned herself conspicuously in the front window, near the street, just behind the restaurant's tantalizing fruit compote display. She does not look up or out but seems completely lost in thought. Perhaps she simply shrinks from the viewer's gaze, willing an invisible wall that might shield her from prying eyes.

Does she wait for someone—someone who will see her in the window and come for her through the door? Will she soon leave—her coat is on—or has she just returned to the refuge of the Automat after a late-night rendezvous somewhere in the cold city? Is she a woman with no place to go, sitting at a table reserved for single ladies yet exposed to everyone who passes by outside or enters through the front door? Is she perhaps a tart, ripe for the taking? Hopper might be making that suggestion by associating her with the sumptuous fruit bowl behind her. Or is she, poignantly, an unwitting temptress? In telling his viewers where the young woman sits—in the Automat—Hopper invited his New York audience to impart their own narrative to this picture, which they could easily supply from their own experiences. Hopper's woman personifies the sentiment expressed by the earlier *New York Times* balladeer: "Where millions throng the mart/Living like a thing apart." Perhaps more to the point, however, Hopper has presented a figure utterly alone and defenseless against our gaze, compelling us to consider more than a place and a character type—he has, in his woman in the Automat, given physical form to the deep human need for social contact by suggesting the human tragedy that loneliness can portend.

That Hopper managed to endow a still and solitary figure with such expressive force signals an intense absorption in his subject, not something easily achieved through the casual observations of even the most dogged café sitter. During periods of inactivity, the Automat was a favorite haunt of Hopper's, and more than once it inspired a picture: Hopper's *Sunlight in a Cafeteria,* of 1958 (cat. no. 6), is a synthesis of people and sensations observed in the Automat at Thirty-first Street and Fifth Avenue and at his favorite Tenth Street cafeteria.[27] But the psychological and sexual tension that emanates from his portrayal of this lone woman in the night may be

the result of the circumstances of his life when he painted *Automat* in 1927. In July 1924, Hopper had married Josephine Nivison, a painter he had met in Gloucester, Massachusetts, the summer before. Nivison was Hopper's contemporary—she was forty-one when they married, and Hopper was just a few days shy of forty-two. Nivison had been, like Hopper, a student of Robert Henri, and she understood probably more than any wife would the demands of her husband's art. With their marriage, Jo became the model for all of Hopper's subsequent painted women. His pictures were now studio productions that evolved from sustained study of his model, and notes and sketches were no longer so necessary to the development of his compositions as they once had been. Pictures could evolve on the canvas as he painted. And out of his own intimacies with the new woman in his life came a deepening focus on womanhood for all its subtlety and emotional intensity.

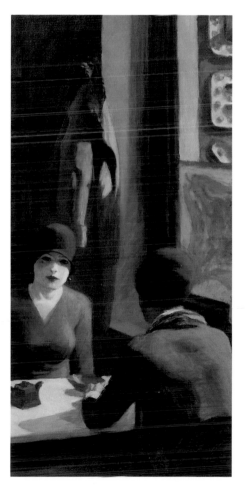

Chop Suey, 1929

In January 1929, Hopper delivered to his dealer Frank K. M. Rehn a restaurant picture he called *Chop Suey* (cat. no. 7). The picture is ambiguous enough in its limited action to invite all manner of speculation as to its meaning, yet Hopper titled the work specifically—as he had done with his earlier *Automat*—firmly grounding the scene in a place known to New Yorkers for the distinctive customs of its hosts and the character of its clientele. The silent individual dramas of two young couples—a pair of smartly dressed girls at center and, at far left, a man dining with a young woman— are made meaningful by situating them in this particular place.

In Hopper's time, few things said New York like the Automat, which he depicted in 1927, and chop suey, the dish for which he titled his next restaurant picture. Chop suey became thoroughly connected with the city in the first decades of the twentieth century and symbolized then, much more than it does now, the cultural confluences that came to define modern Manhattan.

Chop suey has its source in a bit of New York folklore: according to tradition, it was a visit to the city in 1896 by the Chinese general Li Hongzhang that led to the invention of the dish. The general was on an important ambassadorial mission to raise America's consciousness about the Chinese people. A guest at the elegant Waldorf Hotel, the general nevertheless refused to eat American food and asked that his own cooks prepare his meals. Unable to obtain genuine Chinese ingredients anywhere in Manhattan, they reportedly improvised a dish of stir-fried meat and vegetables mixed with steamed rice—*zasui* was the term for it in Mandarin, but "chop suey" is what Americans called it.[28]

In almost no time chop suey was playing an important part in the city's popular culture. By 1903 chop suey restaurants had become synonymous with New York nightlife. Then, before Prohibition, the restaurants were lively, late-night supperclubs where New Yorkers danced to tunes from a player piano and ate heaping platters of chop suey, or, if they were feeling less adventurous, plain American fare like broiled ham or chicken. Chop suey restaurants did not serve authentic Chinese food; they were established by enterprising Chinese cooks to appeal to strictly American tastes. Chop suey eateries became wildly popular among working-class New Yorkers as spots for a gay time and a cheap meal. A chop suey restaurant was, as one writer pointed out, "an alleviating alternative to the young man who could not afford to act as host to a companion, however fair, at a supperclub. The cover charge at a club can . . . easily cover the cost of Chinese comestibles for two, with a sufficient surplus for lunch for a week."[29] Chop suey restaurants soon were found all across the city, especially in areas that catered to the after-theater crowd. The *New York Times* reported in 1903 that more than one hundred chop suey places had sprung up in just a few months across a large swath of Manhattan, between Fourteenth and Forty-fifth streets and from the east-side Bowery to Eighth Avenue.[30]

Like Automats, chop suey restaurants had a particular look and character. Unpretentious places, they were typically located on the upper floors of old commercial brownstones (fig. 9). A large, flashy "chop suey" sign,

Figure 9. Imogen Cunningham
(American, 1883–1976), *Chinatown,
New York City,* 1934
Gelatin silver print, 8 × 10 in.

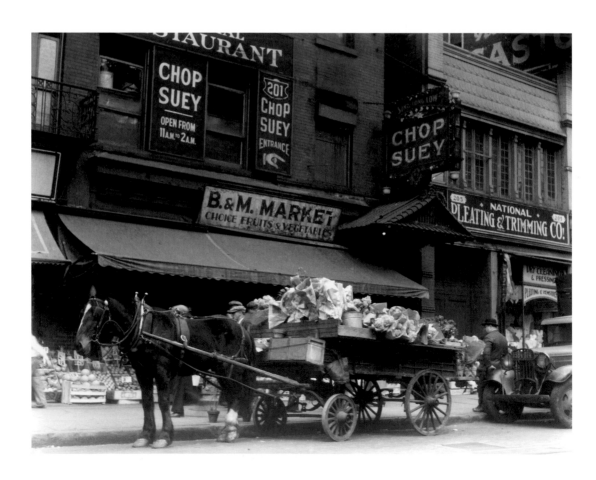

extending prominently from a building's facade, identified the restaurant
to passersby on the street below. Many were open for lunch, but all catered,
at least initially, to a late-night crowd, remaining open as late as 2:00 A.M.
Inside, the restaurants might be decorated with bright, patterned wallpaper
and festive hanging lanterns and paper parasols, but in the service of food,
they were pictures of orderliness. The *New York Times* described a typical
scene in a chop suey restaurant in 1903:

> A Chinese waiter does not talk. It is quite indifferent to him whether
> or not he gets a tip. No matter if he is tipped, nothing will induce
> him to serve a customer out of turn. . . . In the cheaper chop suey
> places, customers are warned by signs on the wall to look after
> their own coats and umbrellas. The tables are of polished wood
> and bare of condiments. . . . The cashier's desk is near the door and
> the customer cannot tell whether his check is correct or not until
> he gets his change. . . . The garments worn by the waiters and others
> about the place are scanty but clean. The culinary arrangements are
> absolutely cut off from view. The cooks and kitchen men are not
> exposed to view as they are in many American restaurants that serve
> food at comparatively the same prices. The Chinaman goes to the
> kitchen for his food instead of bawling the order through an open
> window.[31]

Chop suey restaurants appealed to a widely diverse clientele that
included Irish Catholics, European Jews, and blacks from Harlem. Their
dining rooms provided a snapshot of modern New York. And as the city
changed, the evolution of its social makeup and economic conditions was
necessarily reflected in the character of its most popular dining emporiums,
chop suey eateries included. By the end of 1925, Bertram Reinitz, a popular
social commentator and columnist for the *New York Times,* saw chop suey
as a major indicator of cultural transformation. He wrote reflectively about
the rapid and dramatic physical and social changes, for better or worse,
that the city had seen in the previous months—the continuing prolifera-
tion of motorcars in the grand avenues and the rise of bargain ready-to-
wear emporiums in elegant Union Square, for example. Reinitz pointed to
chop suey as providing another obvious sign of an all-important if subtle
economic shift in an urban population now dominated by the working
classes. "Chop Suey," he declared, had suddenly assumed a "new role."
It had been "promoted to a prominent place in the mid-day menu of the
metropolis." That might seem a small thing, but it reflected a significant
economic reality. Chop suey was no longer merely an entertainment but
was now "a staple . . . vigorously vying with sandwiches and salad as the
noontime nourishment of the young women typists and telephonists of

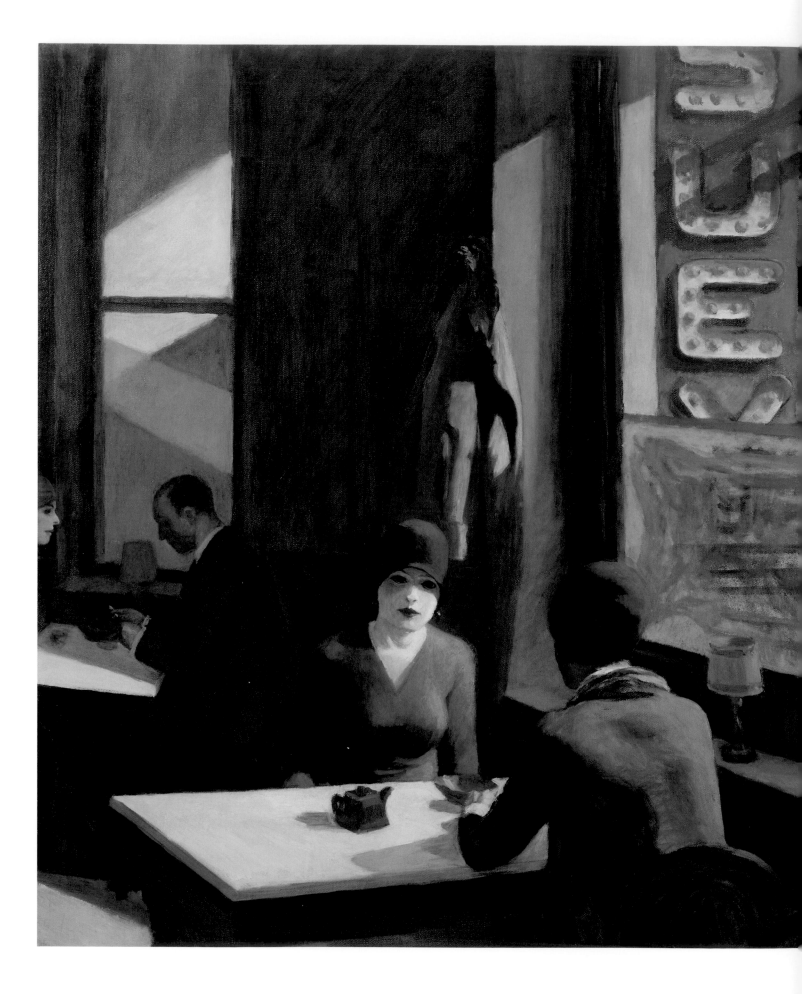

7

Chop Suey, 1929
Oil on canvas, 32 × 38 in., Collection of
Barney A. Ebsworth

John, Dey and Fulton Streets," he said (fig. 10). Chop suey restaurants were now respectable and omnipresent on the local scene, delivering an essential commodity to working-class New Yorkers, especially to the young, single women who had moved into the city's labor force in unprecedented numbers. Chop suey was a "recess repast of the sales forces of West Thirty-fourth Street department stores," Reinitz wrote. "At the lunch hour there is an eager exodus toward Chinatown of the women workers employed in Franklin, Duane and Worth Streets. To them the district is not an intriguing bit of transplanted Orient. It is simply a good place to eat."

American chop suey had also changed the economy and character of Chinatown. Once an enclave of authentic Chinese culture, it was now devoted to the business of supplying chop suey restaurants throughout the greater New York metropolitan region. Chinatown had become, in Reinitz's words, "a coldly commercial center, its thoroughfares choked by mammoth motor trucks loaded with bamboo shoots, soy beans, and dried mushrooms for shipment to wherever in the five boroughs, Long Island, New Jersey, and Connecticut chop suey is chopped." Chinese entrepreneurs were beginning to make their fortunes in American chop suey and could envision a freedom and social mobility that must have been impossible to imagine earlier. "Chop suey, in the opinion of a Doyers Street purveyor of it, seems destined to become a necessary of New York life. . . . He says it is his dream to go back to his Canton home some day and introduce the delectable dish to his fellow-countrymen," Reinitz reported, providing an amusing end to his story. Commercial success had elevated American chop suey in the eyes of its Chinese creators and made it seem an important contribution to their own folkways and modern life.

The working girls who frequented chop suey restaurants at noontime would have been attracted to their distinctive calm and orderliness. They must have seemed peaceful oases to harried shop girls and secretaries who could find brief moments of calm in their midday meals there, and one imagines the dining rooms filled with the soft tones of quiet conversations between girlfriends. "The mechanical pianos that are standard equipment in the restaurants serving this exotic edible are poorly patronized during the day when the diners, unlike the more leisurely guests of the evening, are seeking sustenance, not diversion," Reinitz noted in the *Times*.[32]

Around this same time, Edward and Jo Hopper were frequenting a chop suey restaurant uptown at Columbus Circle, on the west side, in an area not far from the Rehn Gallery, his Fifth Avenue dealer, and other

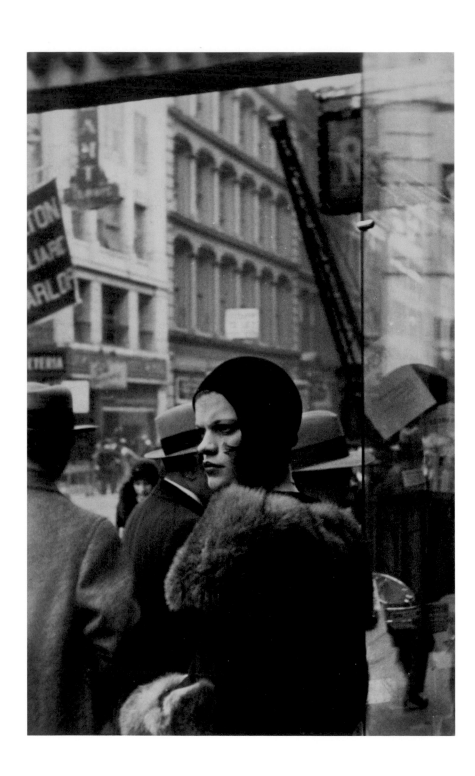

Figure 10. Walker Evans (American, 1903–1975), *Girl in Fulton Street, New York*, 1929
Gelatin silver print, 7½ × 4⅝ in., The Museum of Modern Art, New York, gift of the photographer (SC1988.92)

uptown art galleries.[33] A close observer of men and women in the quotidian aspects of urban life, Hopper would have been keenly sensitive to the human stories played out within the lunchtime routine of the chop suey restaurant. Taken with the open, orderly dining room and the quiet charm of the young working-girl clientele, Hopper was inspired to re-create on canvas the kind of typical scene he witnessed there.

A Chinese restaurant might appeal to some painters for its picturesque charm, but Hopper depicted a plain if not austere place, focusing not on the setting but on the human interaction within it—the conversation of working girls over a pot of Chinese tea. The action that we do not see is as important to the mood of the painting as the view Hopper does give us. The restaurant is calm and still, pleasant if not joyful. Hopper appreciated the fine points of the chop suey dining room and the contrast it would have made with, for instance, the crowded, dehumanizing Automat. In the artist's evolving epic of the modern woman—a series that begins with his *New York Restaurant* of about 1922 and moves next to his dark and plaintive *Automat* of 1927—*Chop Suey* of 1929 offers a hopeful scene. In this pleasant room, wholesome, wide-eyed working girls are served by no-nonsense Chinese waiters, who rarely spoke—they do not even appear in Hopper's picture—and who carefully observed the protocol of the dining room. They offered diners standard fare, a strange, hybrid Chinese-American concoction that was somehow a staple of New York life. Rather than offering the Automat's woeful tale of lonesome women who lived like creatures apart, the story of the chop suey restaurant encompasses the intersecting lives of its working-class hosts and guests. Both the Chinese chop suey restaurateurs and the New York shop girls were new modern urban types; both had assumed new identities far removed from their traditional roles. *Chop Suey* reminds us that Hopper's modern sensibility lay in his profound sensitivity to America as a culture in flux, the impact of which he measured in individual psychological terms.

8 *New York Movie,* 1939
Oil on canvas, 32¼ × 40⅛ in., The Museum of Modern Art, New York, given anonymously (396.1941)

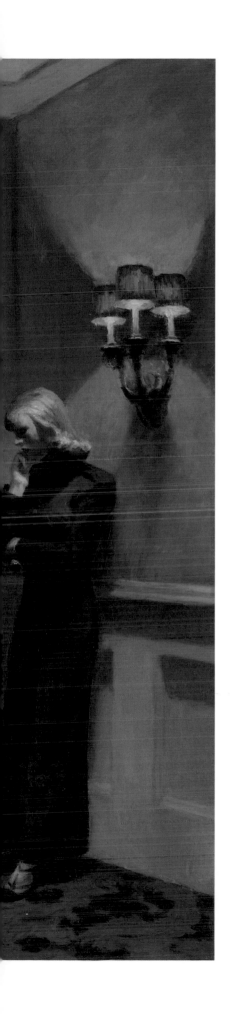

A Persistence of Vision

In every artist's development, the germ of the later work is always found in the earlier. The nucleus around which the artist's intellect builds his work is himself . . . and this changes little from birth to death. What he once was, he always is, with slight modifications.

—Edward Hopper, 1935[34]

Edward Hopper was given a retrospective exhibition at the newly founded Museum of Modern Art in New York in 1933. He was fifty-one years old, but his painting career spanned only some ten years to that point, and there would be three decades of painting to come. Yet, Alfred H. Barr, the museum's director, wrote in his introduction to the show's catalogue that Hopper's art already seemed, surprisingly, "so sure, so consistent," especially after decades of inconsistency.[35] Hopper had labored long in obscurity, initially as just another young American painter of Paris views and then as a magazine illustrator. He found success first as an etcher and, later, as a watercolorist. But by 1933 Hopper had managed to paint many of the oils that established him not just as a painter of distinction but as a modern master, an artist worthy of the singular honor that the country's new modern art museum now bestowed upon him.

Hopper himself clearly believed, as he wrote, above, in 1935, that the direction of his art had been set early and inevitably. He was, he said in 1950, "like Voltaire, who once remarked, 'My book is finished; all I have to do is write it.'"[36] In retrospect, we see that there is an interconnectedness among Hopper's subjects that seems to support his claim that the general sweep of his narrative on modern life was already fully conceived by the time he hit his stride as a painter in the late 1920s. It required only the will and the physical effort to set down in pictures the central ideas he had already formulated

Figure 11 a,b. Walker Evans
(American, 1903–1975), *Street Scene,
New York [Woman in Front of Movie
Poster for "Manhattan Melodrama,"
New York City]*, 1934
Film negative, The Metropolitan Museum of
Art, New York, Walker Evans Archive, 1994
(1994.253.114.1 & .2)

in his mind. Hopper of the 1930s, 1940s, and 1950s is the same artist who was defined in the 1920s by his now iconic *House by the Railroad* (1925, Museum of Modern Art, New York), *Automat* (1927), and *Chop Suey* (1929). These are the defining works, painter Charles Burchfield said in admiration, not simply because they display enduring stylistic characteristics; rather, with them, Hopper quickly laid claim to a set of images that became part of our perception of the modern world. "We speak of Hopper houses," Burchfield said, referring to the antiquated Victorian piles that Hopper painted, houses whose hand-hewn quirkiness speaks of our pre-machine-age past and of the individualism of the people who built and inhabited them, and whose souls still seem to animate them.[37] There are also the white clapboard houses that emanate a Hopper quality of light, which reveals these unassuming structures in all their modern-seeming simplicity. There are as well the rows of Hopper brownstones, worn buildings that have stood in America's cities since the late nineteenth century, the shops and apartment homes of the people who make a city. These brownstones, too, are from a far-off time. Hopper's architecture is a long way from skyscrapers and industrial megaliths, the universal symbols of the modern age. His is the modern age viewed not from on high, but from the point of view of the man and woman on the city street, on the elevated train, or in an automobile passing through an old but changing New England town, like those on Hopper's beloved Cape Cod.

We speak of Hopper houses, but just as frequently we mention Hopper's women. In the Hopper iconography, women loom large. And like his buildings, Hopper's women are figures suspended in time, subjects that embody enduring associations with girlhood, motherhood, and home and hearth, but now, as occupants of offices, cheap restaurants, movie theaters, rooming houses, or motel rooms, they are women strangely out of place.

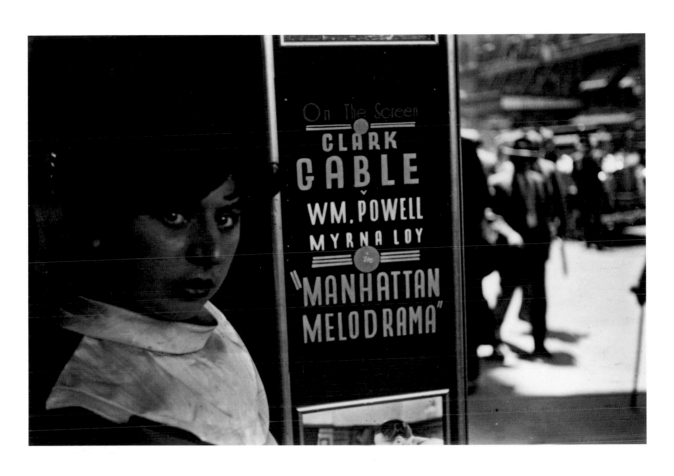

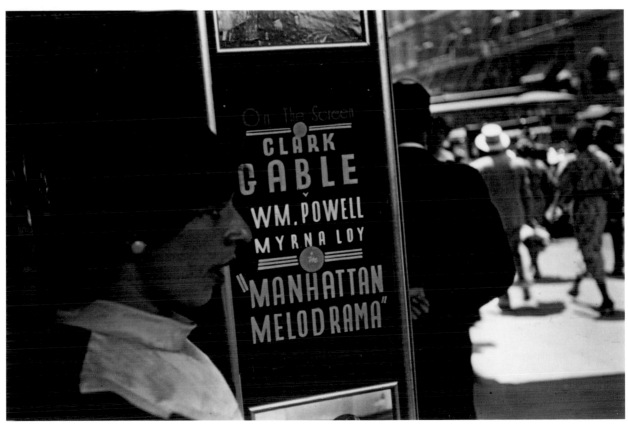

Compartment C, Car 293, 1938
Oil on canvas, 20 × 18 in., private collection

Figure 12. Walker Evans (American,
1903–1975), *Subway, New York*, 1934
Gelatin silver print, 4⅛ × 7 in., Seattle Art Museum,
purchased with funds from the estate of Mary Arrington
Small (86.4.10)

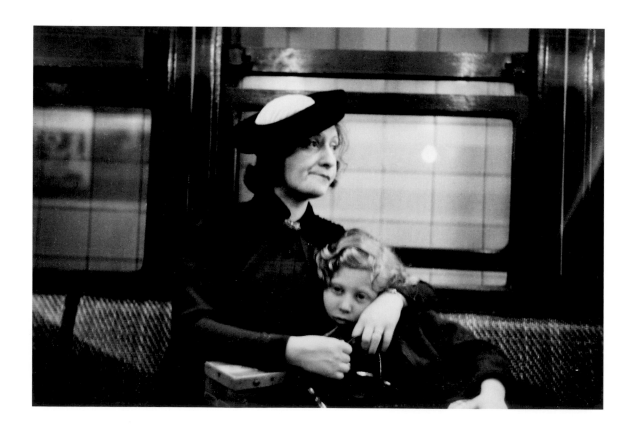

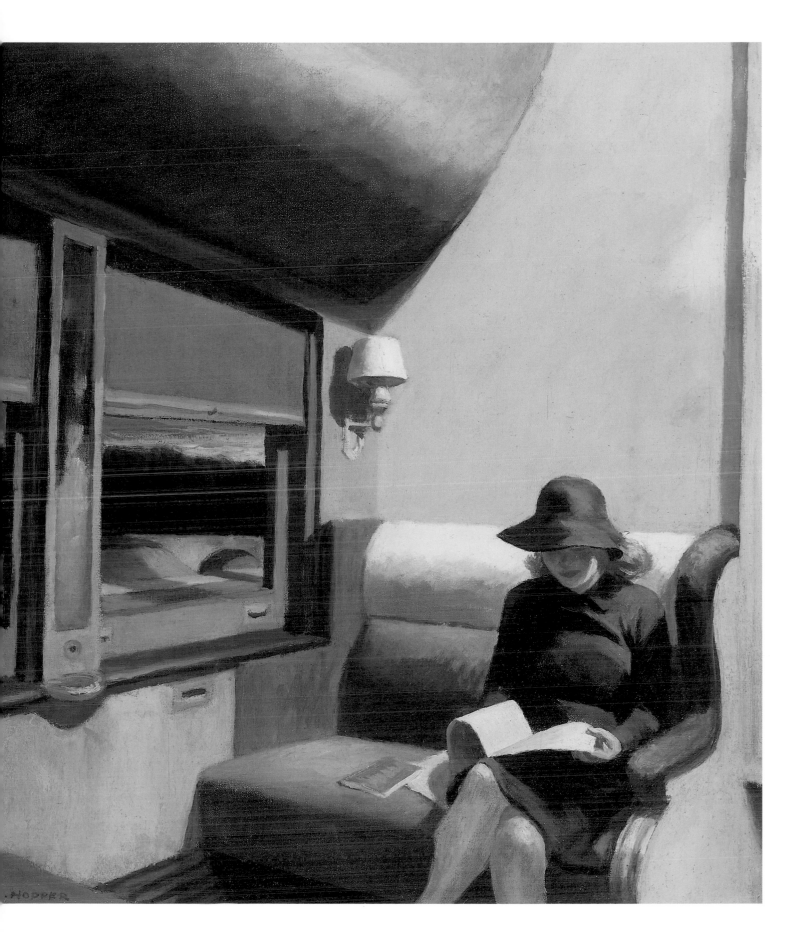

Figure 13. *Western Motel,* 1957
Oil on canvas, 30¼ × 50⅛ in., Yale University Art Gallery, New Haven, bequest of Stephen Carlton Clark, B.A. 1903 (1961.18.32)

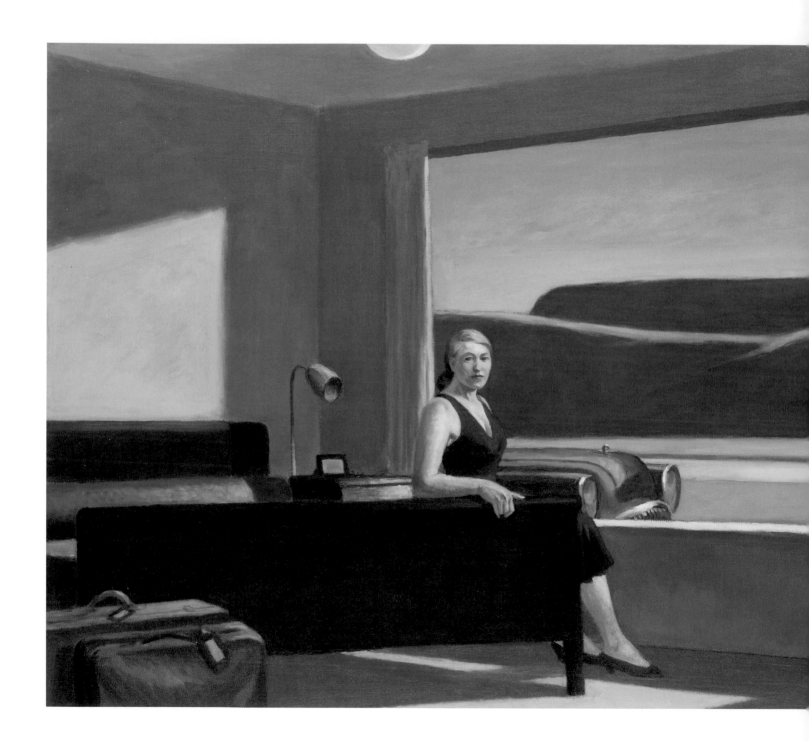

Figure 14. Marion Post Wolcott (American, 1910–1990), *Winter Visitors Picnicking near Trailer Park, Sarasota, Florida,* 1941
Gelatin silver print, 8¾× 12 in., Art Institute of Chicago, gift of Michael D. Wolcott (1988.505.13)

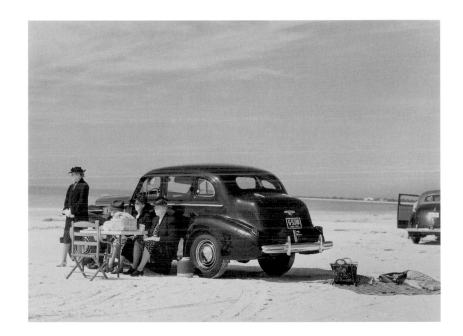

10

"Posterity will be able to learn more about our life of today through looking at Hopper's work than from all the social schools, political comments, or screaming headlines of the present," Burchfield claimed.[38] Though Hopper painted through two world wars and the Great Depression, he had no interest in polemics about brutality and bread lines. It is in this historical context that Hopper's unending focus on the country's women is especially potent, for these events changed the place of women, impelling them out of the home, into the urban workplace, and onto the road as dislocated nomads or seekers of the good life. History changed the look of women, too, Hopper noticed, because he scrutinized them endlessly, as an archaeologist might, attempting to understand the cultural, economic, and social conditions that might have left their impress. Hopper's paintings have a visual equivalent in the documentary work of the period's photographers. Compare, for example, Hopper's *New York Movie* (cat. no. 8) and Walker Evans's *Street Scene, New York* (fig. 11a,b) or Hopper's *Compartment C, Car 293* (cat. no. 9) and Evans's *Subway, New York* (fig. 12). Photographers such as Evans, Berenice Abbott, and Marion Post Wolcott, motivated by feelings of intimacy with and sympathy toward their subjects, trained their cameras on men and women to capture surprising and accidental moments revealing a deeper humanity. These images still arouse our awe and humility.

As historical events changed women, they also changed the way men, Hopper included, viewed women. Hopper's women have ambiguous relationships toward men—the men who occupy Hopper's paintings, and the man himself who made the pictures. In the crowded modern city, a woman's most private moments are on display, though she might not know it. She is either oblivious to or ignoring of a man's gaze. Hopper's women represent the very idea of emotional detachment and can evoke thoughts of what that portends for society and humanity.

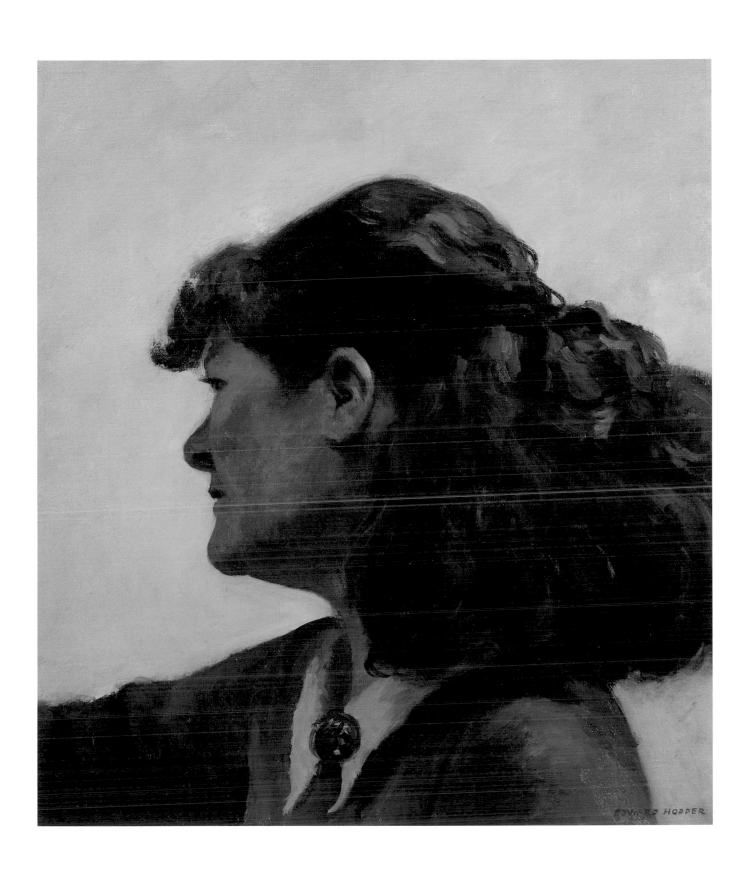

When Hopper considered a woman's frailty, vulnerability, or sexuality, it was, in fact, one woman whom he studied—his wife, Jo, who occupied the central place in his life and his art as lover, companion, muse, business manager, and keeper of the Hopper flame. She was herself a woman who bridged the two worlds that Hopper saw colliding in twentieth-century America, for Jo was a woman born in the Victorian age but shaped by the forces of modern times. When, as his model, she assumed the many different female roles that he assigned to her, Jo accommodated herself to her husband's perceptions of modern women. She accommodated herself to his unspoken fantasies as well, many of them involving much younger women than she and all of them with undeniable sexual overtones—something she could or would not do outside the painting studio, for rather famously she was by nature fiercely independent, shrew-like and, evidence suggests, sexually cold. Hopper was just as famously her reserved, unmovable, stone-like opposite.[39] But in the artist's studio, the tensions that flowed from the tumultuous marriage of this sullen man and this fiery woman energized Hopper's art, inspiring unmatched pictures of human longing—for human contact, for sexual fulfillment—the kind of longing that this painter could never comfortably express in his own life.

Notes

1. Walker Evans, from "People in the Subway: Unposed Portraits Recorded by Walker Evans," 1956–66, reproduced in Sarah Greenough, *Walker Evans: Subways and Streets* (Washington, D.C.: National Gallery of Art, 1991), 125. Brian O'Doherty famously defined Hopper as the man who emerges in the relationship between the "the observer and the observed" in his art, and this introduction refers specifically to O'Doherty's enduring phrase; see Brian O'Doherty, "Edward Hopper's Voice," in *American Masters: The Voice and the Myth* (New York: Random House, 1973), 19.

2. See William Johnson, notes from an interview with Hopper for *Time* magazine, typescript, October 30, 1956, 24, Whitney Museum of American Art Archives, Edward and Josephine Hopper Research Collection.

3. Archer Winsten, "Wake of the News: Washington Square North Boasts Strangers Worth Talking To," *New York Post,* November 26, 1935, 15.

4. Quoted in Brian O'Doherty, "Portrait: Edward Hopper," *Art in America* 52, no. 6 (December 1964): 77.

5. "The Silent Witness," *Time* 68, no. 26 (December 24, 1956): 39.

6. Quoted in O'Doherty, "Edward Hopper's Voice," 16.

7. Diary entry, November 18, 1918, Guy Pène du Bois Papers, Archives of American Art, Smithsonian Institution, quoted in Carol Troyen, "'A Stranger Worth Talking To': Profiles and Portraits of Edward Hopper," in Carol Troyen et al. *Edward Hopper* (Boston: MFA Publications, 2007), 14.

8. Quoted in Greenough, *Walker Evans,* 125.

9. Quoted in Troyen, *Edward Hopper,* 14.

10. Gail Levin, *Edward Hopper: An Intimate Biography* (New York: Alfred A. Knopf, 1995), 50. Hereafter cited as Levin, *Biography.*

11. Hopper to Charles H. Sawyer, Addison Gallery of American Art, Andover Academy, Andover, Massachusetts, October 29, 1939, quoted in ibid., 215.

12. "The Silent Witness."

13. O'Doherty, "Portrait," 76.

14. Hopper, in an interview with Katharine Kuh, in *The Artist's Voice: Talks with Seventeen Artists,* rev. ed. (New York: Harper and Row, 1962), 142.

15. "The Feeding of New York's Down Town Women Workers—a New Social Phenomenon," *New York Times,* October 15, 1905, Sunday Magazine section, page SM7.

16. Hopper in a letter to New York art dealer Maynard Walker, January 9, 1937, quoted in Gail Levin, *Edward Hopper: A Catalogue Raisonné* (New York: Whitney Museum of American Art, in association with W.W. Norton, 1995), 1: 64–65.

17. For a history of waitressing as it developed in America in the first two decades of the twentieth century, see Dorothy Sue Cobble, *Dishing It Out: Waitresses and Their Unions in the Twentieth Century* (Urbana and Chicago: University of Illinois Press, 1991).

18. Pène du Bois, diary entry for November 30, 1918, quoted in Levin, *Biography,* 124–25.

19. From the Hopper archives, quoted in Levin, *Biography,* 144–45. For a full account of this friendship, see pp. 142–45. Levin fully describes the place of Hopper's increasingly erotic etchings in the development of his new figure paintings, and my observations are derived from her thoughtful analysis.

20. For Hopper's *Moonlight Interior,* see Levin, *Edward Hopper: Catalogue Raisonné,* O–239.

21. "Every Man His Own Waiter," *Brooklyn Daily Eagle,* December 22, 1902, 6.

22. "New Yorkville Automat," *New York Times,* December 11, 1927, RE2.

23. "Every Man His Own Waiter."

24. Lorraine B. Diehl and Marianne Hardart, *The Automat: The History, Recipes, and Allure of Horn & Hardart's Masterpiece* (New York: Clarkson Potter, 2002), 33.

25. Florence Van Cleve, "At the Automat," *New York Times,* November 10, 1925, 24.

26. Allen Johnson, "Lonesome," *New York Times,* June 4, 1926, 22.

27. The places are identified in Levin, *Biography,* 517.

28. See J.A.G. Roberts, *China to Chinatown: Chinese Food in the West* (London: Reaktion Books, 2002), 138–39.

29. Bertram Reinitz, "Chop Suey's New Role," *New York Times,* December 27, 1925, XX2.

30. "Chop Suey Resorts: Chinese Dish Now Served in Many Parts of the City," *New York Times,* November 15, 1903, 20.

31. Ibid.

32. Reinitz, "Chop Suey's New Role."

33. Levin, *Biography,* 221.

34. "Edward Hopper Objects," letter to editor Nathaniel Pousette-Dart, in *Art of Today* 6 (February 1935): 11.

35. Alfred H. Barr, Jr., "Edward Hopper," introduction to *Edward Hopper Retrospective Exhibition* (New York: Museum of Modern Art, 1933), 9.

36. Hopper, quoted in Lester Cooke, "Paintings by Edward Hopper," *Russian America,* July 23, 1958, quoted in Levin, *Biography,* 512.

37. Charles Burchfield, "Hopper: Career of Silent Poetry," *Art News* 49 (March 1950): 63.

38. Ibid., 62.

39. See Levin, *Biography,* and Vivien Green Fryd, *Art and the Crisis of Marriage: Edward Hopper and Georgia O'Keeffe* (Chicago: University of Chicago Press, 2003).

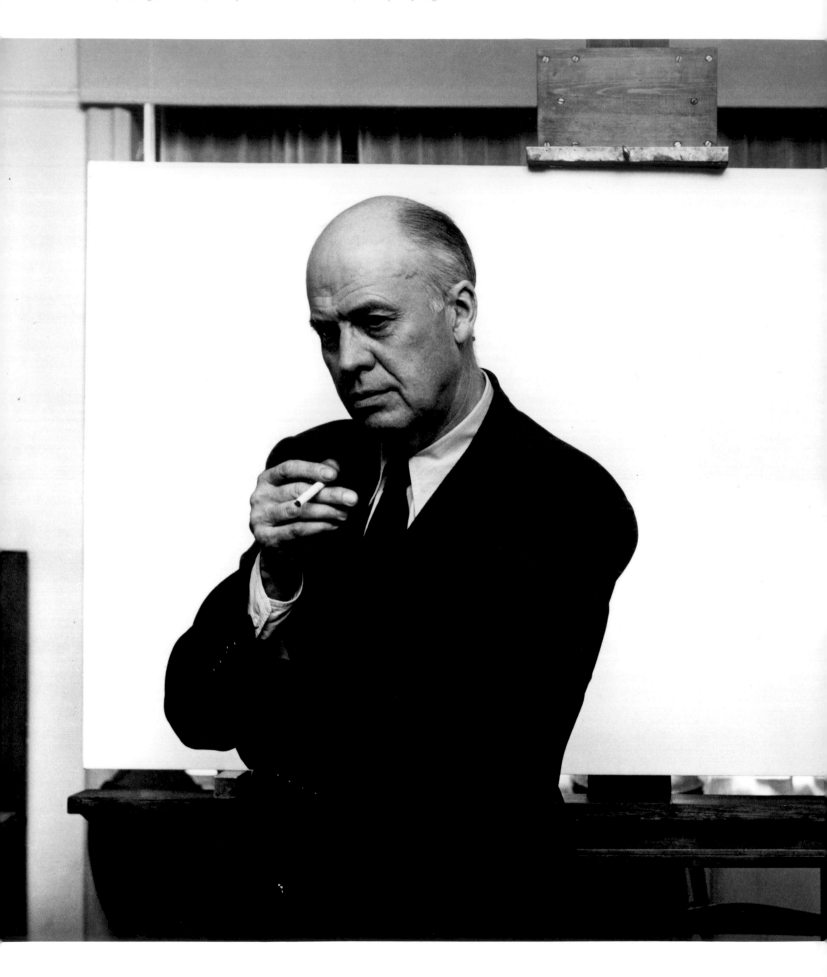

Figure 15. Arnold Newman (American, 1918–2006), *Portrait of Edward Hopper,* 1941
Gelatin silver print, negative 4 × 5 in., formerly collection of Arnold Newman, courtesy Getty Images

Chronology

This timeline is drawn from the detailed chronologies of the artist's life and career in Carol Troyen et al., *Edward Hopper* (Boston: MFA Publications, 2007), and Gail Levin, *Edward Hopper: The Art and the Artist* (New York: W. W. Norton & Co., in association with the Whitney Museum of American Art, 1980).

1882
JULY 22: Edward Hopper is born in Nyack, New York, the second child and first son of Gerret Henry Hopper (1853–1913), a shopkeeper, and Elizabeth Griffiths Smith Hopper (1856–1935).

1899
Hopper enrolls in New York School of Illustrating.

1900–1905
At New York School of Art, Hopper studies illustration before moving to the painting curriculum. Studies painting with William Merritt Chase, the school's founder, and with Robert Henri and Kenneth Hayes Miller. Fellow students include George Bellows, Rockwell Kent, and Guy Pène du Bois.

1906–1910
Hopper makes three trips abroad, favoring Paris, but also visiting London, Amsterdam, Berlin, Brussels, and Madrid.

1906–1925
Hopper works as an illustrator for New York advertising agencies.

1908
The artist settles permanently in New York.

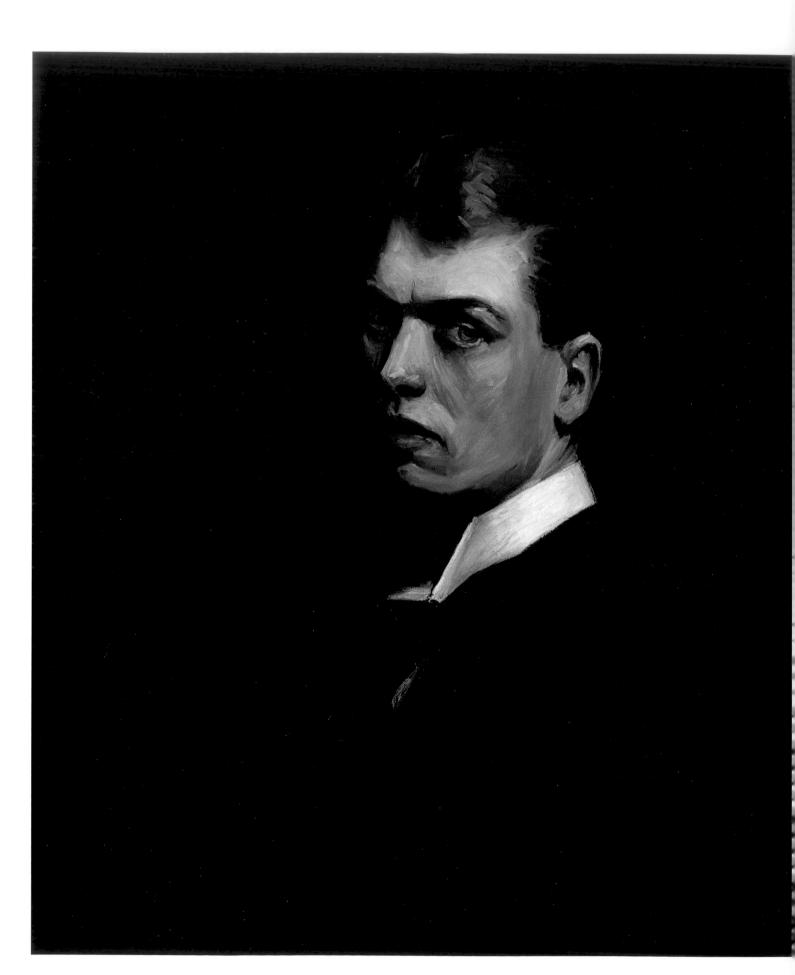

Figure 16. *Self-Portrait,* 1903–6
Oil on canvas, 26 × 22 in., Whitney Museum of
American Art, New York, Josephine N. Hopper
Bequest (70.1253)

1913

FEBRUARY: "International Exhibition of Modern Art," held at the Sixty-ninth Regiment Armory, New York, includes Hopper's *Sailing,* which is sold from the exhibition, marking the artist's first sale of a painting. There will be no further sales of paintings or critical attention given to the artist's oils for another decade.

DECEMBER: Hopper moves to top floor of 3 Washington Square North, the building that would be his home and studio for the rest of his life.

1916

Having taken up printmaking, Hopper purchases a printing press.

The artist makes his first visit to Monhegan, Maine, and travels there to paint during three subsequent summers.

11

Night Shadows, 1921
Etching, 7 × 8⅜ in. (plate), private collection

1920

JANUARY: The artist's first solo show is organized by painter-friend Guy Pène du Bois at the Whitney Studio Club, New York, the first exhibition with a significant representation of Hopper's oils. The show includes mainly earlier Paris canvases and some recent paintings done in Maine.

1923

SUMMER: The artist enjoys a productive painting season in Gloucester, Massachusetts, working in watercolor, and begins the body of work that will bring Hopper his first acclaim in the medium. Meets painter Josephine (Jo) Nivison there.

1924

JULY 9: Hopper marries Jo Nivison. Henceforth she is the model for his figural works.

OCTOBER: First solo exhibition of the artist's watercolors opens at Frank K. M. Rehn Galleries, New York, and its success solidifies his growing reputation as a watercolorist.

1925

FEBRUARY: The Pennsylvania Academy of the Fine Arts in Philadelphia buys *Apartment Houses,* 1923, marking Hopper's first sale of an oil to a public institution.

1930

JANUARY: Patron Stephen C. Clark donates *House by the Railroad* to the Museum of Modern Art, New York, making it the first oil by any artist to

Figure 17. Louise Dahl-Wolfe
(American, 1895–1989),
*Edward Hopper and Wife,
New York,* 1933
Gelatin silver print, 8⅞ × 7⅝ in., Center
for Creative Photography, University of
Arizona, Tucson, Louise Dahl-Wolfe
Archive/Gift of the Louise Dahl-Wolfe
Trust (85:102:012)

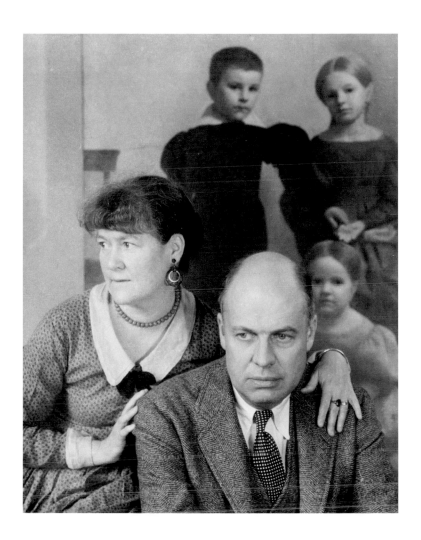

enter the new modern museum's collection and spurring the institution's commitment to exhibiting and collecting Hopper's work.

1931

NOVEMBER: Whitney Museum of American Art opens on Eighth Street in lower Manhattan with Hopper's *Early Sunday Morning* in its permanent collection. With this acquisition, Hopper had gained representation at all the major New York museums, including the Metropolitan Museum of Art, the Museum of Modern Art, and the Brooklyn Museum.

1933

OCTOBER: The Hoppers buy land on Cape Cod, in South Truro, Massachusetts, and will complete a home there the following year, making Cape Cod a locus of painting activity for the rest of the artist's life.

NOVEMBER: Retrospective exhibition at the Museum of Modern Art, New York, organized by Alfred H. Barr, Jr. Purchases for the museum's collection will follow, along with an additional gift from devoted patron Stephen C. Clark, making MoMA an important repository for Hopper's early paintings.

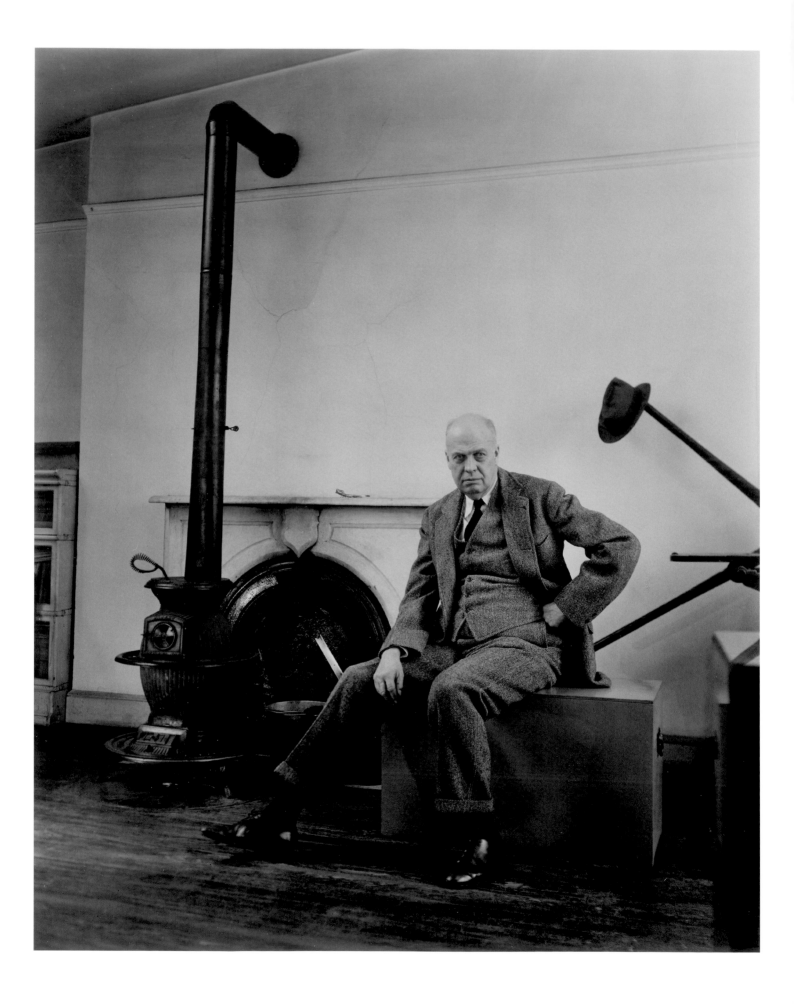

Figure 18. Berenice Abbott
(American, 1898–1991),
*Edward Hopper, Greenwich Village,
New York*, 1947–48
Gelatin silver print, 15⅞ × 12⅞ in., The Art
Institute of Chicago, Peabody Fund (1951.258)

1950

FEBRUARY: Retrospective exhibition at Whitney Museum of American Art,
New York, organized by Lloyd Goodrich, who will become the foremost
chronicler of Hopper's career.

1962

OCTOBER: Exhibition of the complete body of Hopper's graphic work is
organized by the Philadelphia Museum of Art.

1964

SEPTEMBER: Retrospective exhibition at New York's Whitney Museum of
American Art is the second in fourteen years mounted by the institution.

1966

NOVEMBER: Hopper completes his last painting.

1967

MAY 15: Hopper dies in New York City at age eighty-four.

1968

MARCH 6: Jo Hopper dies, bequeathing to the Whitney Museum of American
Art the Hopper estate, with more than three thousand works—oils, watercolors,
prints, sketches, and archival materials.

Selected Bibliography

American Artists Group. *Edward Hopper.* New York: American Artists Group, 1945.

Barr, Alfred H., Jr. *Edward Hopper: Retrospective Exhibition.* New York: Museum of Modern Art, 1933.

Berman, Avis. *Edward Hopper's New York.* San Francisco: Pomegranate Press, 2005.

———. "Hopper." *Smithsonian* 38, no. 4 (July 2007): 57–65.

Brace, Ernest. "Edward Hopper." *Magazine of Art* 30 (May 1937): 274–80.

Burchfield, Charles. "Hopper: Career of Silent Poetry." *Art News* 49 (March 1950): 14–17, 62–63.

Cobble, Dorothy. *Dishing It Out: Waitresses and Their Unions in the Twentieth Century.* Urbana and Chicago: University of Illinois Press, 1991.

Crowninshield, Frank. "A Series of American Artists, No. 3—Edward Hopper." *Vanity Fair* 38 (June 1932): 11, 30–31.

Diehl, Lorraine B., and Marianne Hardart. *The Automat: The History, Recipes, and Allure of Horn and Hardart's Masterpiece.* New York: Clarkson Potter, 2002.

Feeney, Mark. "In a Lonely Place; In Hopper's Art, Film Noir, and Elsewhere, Solitude is All-American." *Boston Globe,* July 8, 2007.

Fryd, Vivien Green. *Art and the Crisis of Marriage: Edward Hopper and Georgia O'Keeffe.* Chicago: University of Chicago Press, 2003.

Goodrich, Lloyd. *Edward Hopper.* Harmondsworth, England: Penguin Press, 1940.

———. *Edward Hopper.* New York: Whitney Museum of American Art, 1964.

———. *Edward Hopper: Selections from the Hopper Bequest to the Whitney Museum of American Art*. New York: Whitney Museum of American Art, 1971.

Hobbs, Robert. *Edward Hopper*. New York: Harry N. Abrams, in association with the National Museum of American Art, Smithsonian Institution, 1987.

Hopper, Edward. "Edward Hopper Objects." Letter to the editor, Nathaniel Pousette-Dart. *Art of Today* 6, no. 2 (February 1935), 11.

———. "Notes on Painting." In Alfred H. Barr, Jr., *Edward Hopper: Retrospective Exhibition*, 17–18. New York: Museum of Modern Art, 1933.

Johnson, Robert Flynn. *America Observed: Edward Hopper, Walker Evans*. San Francisco: Fine Arts Museums of San Francisco, 1976.

Kuh, Katharine. "Edward Hopper." In *The Artist's Voice: Talks with Seventeen Artists*, 130–42. Rev. ed. New York: Harper and Row, 1962.

Levin, Gail. *Edward Hopper: The Art and the Artist*. New York: W. W. Norton and the Whitney Museum of American Art, 1980.

———. *Edward Hopper as Illustrator*. New York: W. W. Norton, in association with the Whitney Museum of American Art, 1979.

———. *Edward Hopper: A Catalogue Raisonné*. 4 vols. New York: Whitney Museum of American Art, in association with W. W. Norton, 1995.

———. *Edward Hopper: The Complete Prints*. New York: W. W. Norton, in association with the Whitney Museum of American Art, 1979.

———. *Edward Hopper: An Intimate Biography*. New York: Alfred A. Knopf, 1995.

———, ed. "Edward Hopper Symposium at the Whitney Museum of American Art." *Art Journal* 41, no. 2 (Summer 1981): 115–60.

———, ed. *The Poetry of Solitude: A Tribute to Edward Hopper*. New York: Universe Publishing, 1995.

Lyons, Deborah. *Edward Hopper: A Journal of His Work*. New York: Whitney Museum of American Art, in association with W. W. Norton, 1997.

Lyons, Deborah, and Adam D. Weinberg. *Edward Hopper and the American Imagination*. Edited by Julie Grant. New York: Whitney Museum of American Art, in association with W. W. Norton, 1995.

McRoberts, Jerry William. "The Conservative Realists' Image of America in the 1920s: Modernism, Traditionalism, and Nationalism." PhD diss., University of Illinois at Urbana-Champaign, 1980.

Morse, John. "Edward Hopper: An Interview." *Art in America* 48 (Spring 1960): 60–63.

O'Doherty, Brian. "Edward Hopper's Voice." In *American Masters: The Voice and the Myth in Modern Art,* 1–46. New York: E. P. Dutton, 1974.

———. "Portrait: Edward Hopper." *Art in America* 52, no. 6 (December 1964): 68–88.

Pène du Bois, Guy. "The American Paintings of Edward Hopper." *Creative Art* 8 (March 1931): 187–91.

———. *Edward Hopper.* American Artists Series. New York: Whitney Museum of American Art, 1931.

Rodman, Selden. "Edward Hopper." In *Conversations with Artists,* 198–200. New York: Devin-Adair, 1957.

Silberman, Robert. "Edward Hopper and the Theater of the Mind: Vision, Spectacle, and the Spectator." In *On the Edge of Your Seat: Popular Theater and Film in Early Twentieth-Century American Art,* 137–55. Edited by Patricia McDonnell. New Haven: Yale University Press, in association with the Frederick R. Weisman Art Museum, University of Minnesota, 2002.

Souter, Gerry. *Edward Hopper: Light and Dark.* New York: Parkstone Press, 2007.

Strand, Mark. *Hopper.* New York: Alfred A. Knopf, 2001.

"The Silent Witness." *Time* 68, no. 26 (December 24, 1956): 28, 37–39.

Trachtenberg, Alan. *Reading American Photographs: Images as History, Mathew Brady to Walker Evans.* New York: Hill and Wang, 1989.

Troyen, Carol, et al. *Edward Hopper.* Boston: MFA Publications, 2007.

Updike, John. "Early Sunday Morning." In *Still Looking: Essays on American Art,* 195–99. New York: Knopf, 2005.

———. "Hopper's Polluted Silence." In *Still Looking: Essays on American Art,* 179–93. New York: Knopf, 2005.

Ward, J. A. *American Silences: The Realism of James Agee, Walker Evans, and Edward Hopper.* Baton Rouge: Louisiana State University Press, 1985.

Watson, Forbes. "A Note on Edward Hopper." *Vanity Fair* 31 (February 1929): 64, 98, 107.

———. *The Arts Portfolio Series: Edward Hopper.* New York: Arts Publishing, 1930.

Weinberg, H. Barbara, et al. *American Impressionism and Realism: The Painting of Modern Life, 1885–1915.* New York: The Metropolitan Museum of Art, 1994.

Wells, Walter. *Silent Theater: The Art of Edward Hopper.* London and New York: Phaidon Press, 2007.

Westerbeck, Colin, and Joel Meyerowitz. *Bystander: A History of Street Photography.* Boston: Little Brown, 1994.

Winsten, Archer. "Wake of the News: Washington Square North Boasts Strangers Worth Talking To." *New York Post,* November 26, 1935, 15.

This book has been published in conjunction
with the exhibition *Edward Hopper's Women*,
organized by the Seattle Art Museum and
on view at the Seattle Art Museum downtown
from November 13, 2008, through March 1, 2009

Presenting Sponsor

Safeco Insurance
FOUNDATION.

Publication Sponsor

Wyeth Foundation for American Art

Major Sponsor

THE SEATTLE ART MUSEUM
SUPPORTERS

Unless otherwise noted, all works are by Edward Hopper.
For dimensions given, height precedes width.

Copyright and Photo Credits
Images are reproduced courtesy of their owners/lending institutions.
cat. no. 8: © The Museum of Modern Art/Licensed by SCALA/Art
 Resource, NY
fig. 1: © Estate of Morris Engel
fig. 2: Image courtesy of the Whitney Museum of American Art,
 New York
figs. 3, 4, 7, 16 and cat. no. 10: © Heirs of Josephine N. Hopper,
 licensed by the Whitney Museum of American Art
fig. 5: © The Metropolitan Museum of Art
fig. 9: © Imogen Cunningham Trust
fig. 10: © The Museum of Modern Art/Licensed by SCALA/Art
 Resource, NY; © Walker Evans Archive, The Metropolitan
 Museum of Art
figs. 11 a,b, 12: © Walker Evans Archive, The Metropolitan Museum
 of Art. Fig. 12 photo by Susan Cole.
fig. 14: © Marion Post Wolcott Estate
fig. 15: © Arnold Newman/Getty Images
fig. 17: © 1989 Arizona Board of Regents
fig. 18: © Berenice Abbott/Commerce Graphics, NYC

Details
Front and back cover: Arnold Newman, *Portrait of Edward Hopper*,
 1941 (fig. 15)
Front cover and pp. 2–3: *Chop Suey*, 1929 (cat. no. 7)
Back cover and p. 5: *New York Movie*, 1939 (cat. no. 8)
p. 17: *New York Restaurant*, c. 1922 (cat. no. 2)
p. 24: *Automat*, 1927 (cat. no. 5)
p. 33: *Chop Suey*, 1929 (cat. no. 7)

Library of Congress Cataloging-in-Publication Data

Junker, Patricia A.
 Edward Hopper: women / Patricia Junker.—1st ed.
 p. cm.
 Published in conjunction with an exhibition held at the Seattle
Art Museum, Nov. 13, 2008–Mar. 1, 2009.
 Includes bibliographical references.
 ISBN 978-0-932216-61-8
 1. Hopper, Edward, 1882–1967—Exhibitions. 2. Women in
art—Exhibitions. I. Hopper, Edward, 1882–1967. II. Seattle Art
Museum. III. Title. IV. Title: Women.
ND237.H75A4 2008
759.13—dc22 2008036526

Edited by Suzanne Kotz
Proofread by Jessica Eber
Designed by John Hubbard
Typeset by Maggie Lee
Produced by Marquand Books, Inc., Seattle
 www.marquand.com
Color management by iocolor, Seattle
Printed and bound by CS Graphics Pte., Ltd., Singapore